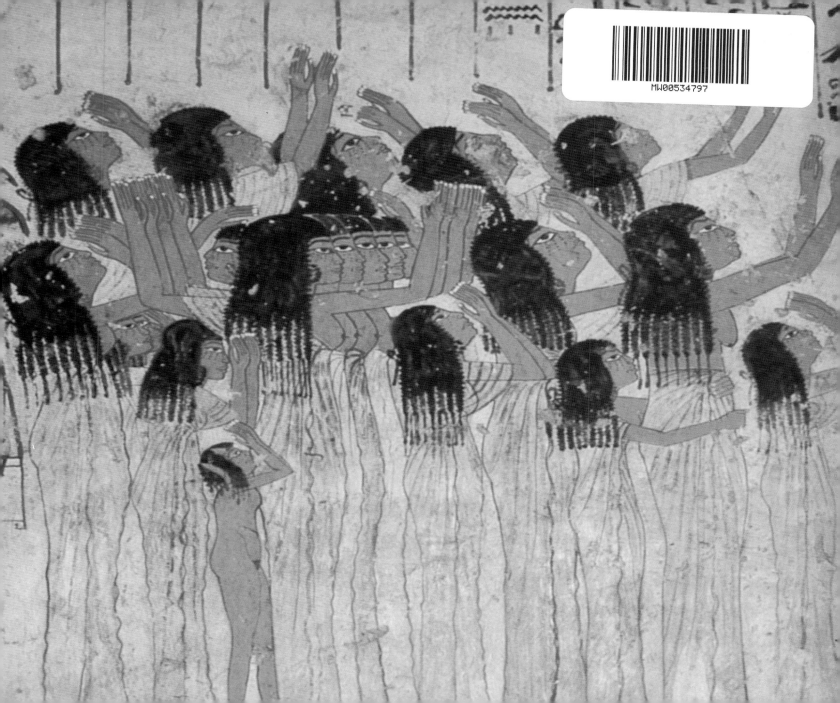

EGYPTIAN EROTICA

The Essence of Ancient Egyptian Erotica in Art and Literature

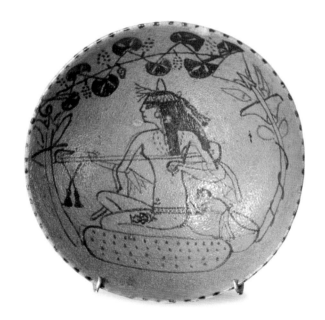

El-Qhamid and Joseph Toledano

Cover Design: Na'ama Yaffe
Language Consultant: Marion Duman
Layout and Graphics: Daniel Akerman
Production Manager: Dan Gold

P.O. Box 1123, Hod Hasharon 45111, Israel
Tel: 972-9-7412044
Fax: 972-97442714

ISBN 965-494-167-8

Published by Astrolog Publishing House 2004

Contents

Timeline

4500-3000 BC	Predynastic Period
3100-2890 BC	Early Dynastic: Dynasty 1
2890-2686 BC	Early Dynastic: Dynasty 2
2686-2613 BC	Early Dynastic: Dynasty 3
2613-2494 BC	Old Kingdom Dynasty 4
2494-2345 BC	Old Kingdom Dynasty 5
2345-2181 BC	Old Kingdom Dynasty 6
2181-2125 BC	Old Kingdom Dynasties 7 & 8
2125-2025 BC	First Intermediate Period: Dynasties 9-11
2025-1700 BC	Middle Kingdom Dynasties 11-13
1700-1550 BC	Second Intermediate Period Dynasty 13-17
1550-1295 BC	New Kingdom Dynasty 18
1295-1186 BC	New Kingdom Dynasty 19
1186-1069 BC	New Kingdom Dynasty 20
1069-945 BC	Third Intermediate Period Dynasty 21
945-727 BC	Third Intermediate Period Dynasties 22-23
727-332 BC	Late Period Dynasties 24-30 and Persian Occupation
332-30 BC	Ptolemaic Period
30 BC-330 AD	Roman Period
330-641 AD	Byzantine Period

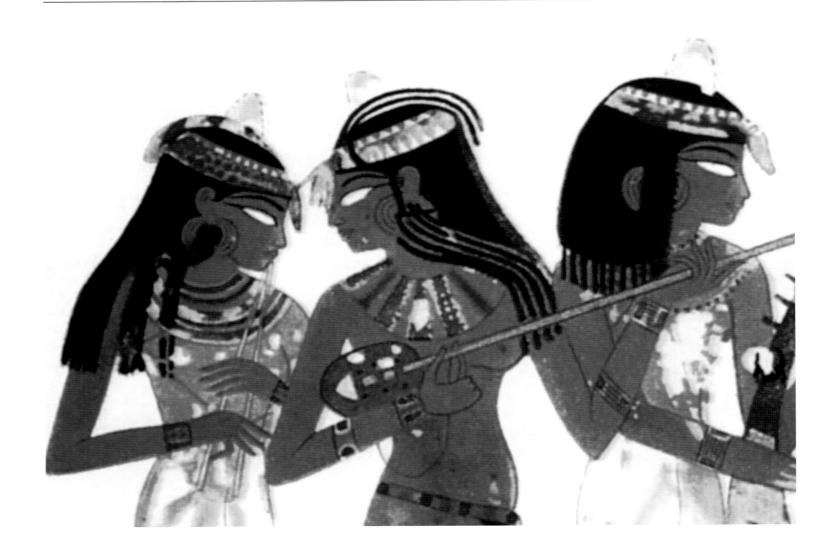

Introduction

When we began to investigate the manifestations of erotica in the ancient Egyptian culture, we hoped that we would amass a large number of sources. After all, we're talking about a culture that endured uninterrupted for thousands of years – longer than any other culture – and had ties with many different cultures, from the cultures and societies in the heart of Africa, about which little is known, to the cultures of Greece, Rome, ancient Israel, Persia and India.

Even after spending close to two years gathering sources, we did not manage to fill one-quarter of the bookshelves we had allocated to this end. At the same time, we enviously watched one of our friends – a researcher by the name of Fred Vitaney, who was conducting an anthropological study of a small group of islands in the Pacific Ocean – collect hundreds of books and detailed reports written by researchers who had reached the islands. Fred would taunt us by saying that three horny anthropologists who had visited the South Sea Islands had left more studies on erotica than hundreds of thousands of researchers who had visited ancient Egypt or sifted through its remains. The well-known Herodotus, who visited Egypt, writes that he had "heard about an Egyptian woman who had copulated with a ram." "Heard" – he didn't see, he didn't go to see, he didn't ask questions. Fred showed us a thick book, a private edition, consisting of 238 pages and 63 black-and-white pictures, dedicated in its entirety to the coupling of an island women with a pigs. The author/illustrator was a missionary who adopted the name "Father Martinock." In the preface, he writes that after hearing about this strange custom, he promised gifts, including colored beads, to anyone who would demonstrate it to him. The result was that a few weeks later, the island women were adorned with beads, and Father Martinock mentioned that he had

seen "…eighty-three different women of between ten and fifty copulating with pigs… I saw most of the women several times, but always with the same pig… In total, I saw more than three hundred acts of abomination…" While we do not want to judge the morality of the missionary in question, the outcome is a detailed study about a topic to which Herodotus barely dedicated a single line.

Unfortunately, the sources that researchers of Egyptian erotica have at their disposal are skimpy. They include:

● Objets d'art or ornaments – pottery, statues, wall paintings, papyri, parchment scrolls and ostraca.
● Various Egyptian texts, mainly in the form of love poems.
● Various Egyptian texts that deal with wizardry, adventure stories, myths, medicine, dream interpretation and calendar diaries with entries regarding sexual customs.
● Texts of researchers and travelers who write about Egypt.

Another fact that limits Egyptologists' research is the "censorship" that researchers and collectors imposed on manifestations of erotica in the Egyptian culture. The testimonies to defacement, concealment and falsification began in the distant past and continue to the present day. A Greek merchant, who kept a log of his journeys in the third century AD, mentions that "…we removed those parts [in which there were pornographic pictures] from those papyri, because it is possible to sell papyri all over [Asia Minor], but the [pornographic] pictures lower their price."

In the 17th century, a Moslem preacher sent his followers, armed with hammers and chisels, to disfigure Egyptian statues that displayed exposed genitals. In his notes, Enrique Posse, one of the members of the famous delegation Napoleon sent to Egypt in order to document its antiquities, made mention of pottery "cards" featuring erotic etchings. Enrique was summoned to the head of the delegation, his notes were burned, and when he protested, he was made to crush the pottery cards into

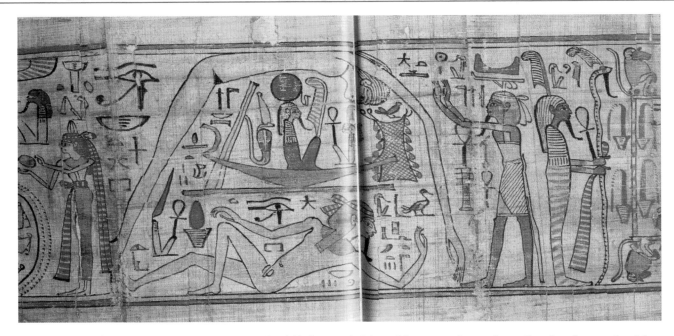

dust, thus condemning them to eternal oblivion. El-Qhamid remembers that: "... In the antiquities warehouse in Cairo where I worked as a boy, the foreman would use chalk to mark the overly "risqué" bits of papyri, pottery, leather scrolls or statues, and we would conceal these bits (sometimes to the point of obliterating them completely). The only penis that remained intact was the one that belonged to a statue of Min, which stood in the foreman's office, and even that penis was used principally for him to hang his hat on". And it did not end with pictures. A detailed 17th-century study of sex customs in the city of Siva (on the border of Egypt and Libya) – a city that upheld the sex customs of the ancient Egyptians and was considered to be a city that was steeped in sex and debauchery in the 20th century as well – was censored with a pair of scissors. The pages that were cut out served as tinder for the coal fire used for heating water. Joseph Toledano remembers that when he was in the Sinai Desert in 1967, near

the Santa Caterina monastery, he came across an ancient quarry that supplied building blocks. The quarry was surrounded by a wall that was covered with erotic drawings – etchings that had been made by an amateur artist in his free time and had an obvious Egyptian flavor. Joseph uncovered the drawings and copied them in a notebook (and I draw very badly. J.). When he returned to the same place two weeks later with a camera, he found that the wall had been smashed and the drawings had disappeared completely. This may have been done by robbers of antiquities, by Moslem Bedouins, or by the monks from the nearby monastery. And if you think that this is an exaggeration, take a look at the famous Turin papyrus. There are differences of opinion as to what percentage of the papyrus has been defaced (some people estimate that some 50 percent of it has been disfigured), but no one disputes the fact that it was defaced mainly in order to obliterate the erotic drawings.

Those are the sources that have been used up till now in the research of Egyptian erotica. In order to grasp how skimpy they are, we only have to look at the chapter on the renowned Turin papyrus, the jewel in the crown of Egyptian love scrolls. In comparison with Indian, Chinese or Japanese scrolls, the Turin papyrus is nothing but a miserable scribble; and yet it is the best-known Egyptian love scroll!

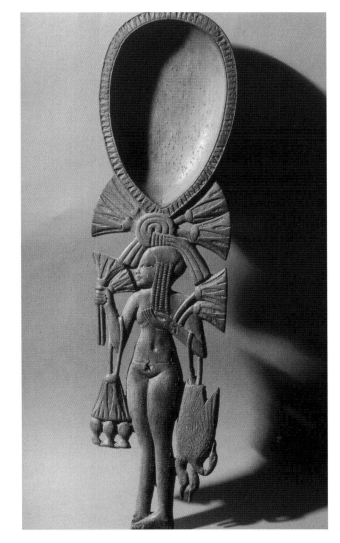

An Overview of Egyptian Erotica

Egyptian erotica – erotica in the narrow sense of presenting the sexuality that prevailed in a particular culture – is reflected in a range of sources: (1) in the graphic arts such as papyri, wall paintings, stone etchings or statues, and even in the design of useful household utensils; (2) in the arts that were mainly expressed verbally (since the knowledge of reading and writing were not widespread) such as poetry, storytelling, oaths and spells; and (3) in the "practical" arts such as medical texts, books on dream interpretation, astrological almanacs, and travel books. Taking into account the long and fairly unbroken history of ancient Egypt, the sources that have reached us today are few, and most of them have not been preserved in their original condition or in their entirety. Generally speaking, it can be said that the legible texts originate mainly from the half-millennium between the 16th and the 11th centuries BC (the New Kingdom period), a period in which the pharaohs were the driving force behind Egyptian culture (and its erotica), while the visible items – statues, paintings and amulets – appeared during a later period that began in the third century BC and was influenced by cultures north of Egypt such as Greece and Rome.

As in other ancient cultures, Egyptian sexuality (and eroticism) was linked to a religious world-view and went through four stages of development: the primitive stage of the ancient kingdom in which there are only hints of eroticism; the symbolic stage in which sexuality and sexual codes are represented by religious symbols; the cultural stage in which eroticism occurs as a part of the entire culture, which included language, art and medicine; and the extreme erotic stage, in which eroticism and sexuality are maximized. This stage comes to the fore from the Ptolemy dynasty onward in Egypt.

The gods of Egypt lived in a family of gods. While each god had his/her own sexual identity, the gods

of the pharaohs and nobles. When one of the pharaohs died, all of his adventures, including his sexual conquests, were recounted on the walls of his tomb or his commemorative stele. "He copulated with one hundred slaves in one night!" declares the inscription on the wall of one of the pharaohs. The pharaohs tried to cross the thin line between the family of the gods and themselves: they would marry within the family – usually their sisters or daughters – and in a strange ritual, they would dedicate their eldest son to the god Amun. That would be accomplished by having their wives copulate with the god in order to conceive an eldest son. Every royal woman would describe in minute detail how the god had come to her bed and had sex with her. The Egyptian pharaoh, Queen Hatshepsut, instigated this refreshing change, and it is said that she spent "a thousand nights searching for [the person who looked like] the god" among the men of Egypt. It should be remembered that in other cultures, including the classical Greek culture, there was a custom whereby one would go off to a house in order to consort with the god in privacy. Women would retire to an isolated place where the god would copulate with them.

The Milan Papyrus, which featured extensively in the New York Times several years ago, was written in the third century BC by the Greek-Macedonian poet, Posidious, who was the "court poet" of Ptolemy II in Alexandria. It is, in fact, the most ancient collection of poems known to us from Egypt (or Greece). The papyrus was found among mummy shrouds, and it is kept at the University of Milan, which also published photographs of it. Incidentally, the scroll was purchased by the university from a private businessman for one million dollars. Posidious himself is well known. A collection of poetry from the second century BC contains several dozen erotic/pornographic poems that are attributed to him. In this book, however, out of the 112 poems (630 lines) it contains, there are only two lines that can be described as having an erotic connotation ("…Like virile stallions the men came to the two, whores whose names were renowned all over the kingdom, the two had a contest – who would win?…"). In other words, even the book written by a poet who was reputed to be "erotic" barely contained any erotic poetry.

The most blatant expressions of eroticism in ancient Egypt appeared during the fifth century BC. The focal point of the works (clay or stone sculptures) is usually a man with a gigantic phallus. There is no doubt that originally, every statue of a man was accompanied by one or more figures of women, but those have not survived. However, it is clear that originally a great deal of importance was attributed to the existence of various partners to the act of intercourse – for instance, slaves or young girls who helped carry the enormous phallus, or female musicians and dancers who urged the couple on.

The written, or more precisely, painted source that is central to understanding Egyptian eroticism reached us from the time of the New Kingdom, and that is the Turin Papyrus 55001, which is known as the Erotic Papyrus of Turin. (We will present it in detail later on.) The papyrus is now kept in the Museo Egizio in Turin, and as far as we know, special arrangements have to be made to view it. Many interpretations have been made of the Turin Papyrus, and everyone can see what he/she wants to see in it. It is obvious, however, that it depicts an orgy, and several different men and women are clearly

identifiable, as are a number of assistants. Each of the dozen pictures explicitly describes a different sexual activity, and a little text accompanies the pictures – just like an erotic comic book. The characters are surrounded by sexual aids – lotus flowers, musical instruments, cosmetics, a pillow, a bed, a balancing sack (see the description of the papyrus for its function), a chair, a jar that is used for masturbation, and so on. In addition, the second part of the Turin papyrus contains pictures of animals, two of which are also featured in the erotic part (the monkey and the goose's head on the harp), and are linked to Egyptian erotica, mainly because of the fact that women were forbidden to use them for masturbation or intercourse.

The Turin Papyrus was found in a place called Deir el-Medina, and this is very important. This village was the center for the builders, stonemasons and artists who built the tombs in the nearby Valley of the Kings. Many ostraca (potsherds) of an erotic nature were found in its vicinity, as were numerous erotic paintings on the walls of the houses and etchings on the stone walls of the surrounding quarries. Among other things, a decorated brothel whose inhabitants were depicted bearing tattoos

of Bes, the god of passion, was discovered. It can be concluded that this village served as a major center for artists who produced and sold erotic works to tourists and nobles who came there to oversee the building of their tombs in the Valley of the Kings. There is a striking similarity among the various works, and it is obvious that they were not produced as the result of a one-time whim, but rather by artists who worked on a "production line". If the supply existed, it is reasonable to assume that there was also a great demand for the products. The immense importance that was ascribed to sexuality in ancient Egypt among the members of the lower classes was reflected in archeological finds. In almost every residential structure we find a central room in which there was a wide bed. There is also evidence of pillows, head supports, and accessories such as musical instruments. These items, which may seem self-evident nowadays, were not an indispensable part of the equipment in every home in ancient times. Further evidence is provided by the frequently recurring sexual symbols and aids in Egyptian literature and art – the lotus flower, the mandrake, musical instruments, female dancers and musicians, and so on.

Ritual prostitution was widespread in cultures around Egypt, and centers for worshiping the gods also served as brothels "for the glory of the god". As a result of this ritual prostitution, holy places were decorated with erotic paintings and sculptures that served as advertisements. Institutionalized ritual prostitution did not exist in Egypt, even though Strabo, a Greek historian who visited Egypt in 25 BC, mentions the prostitution of children in the temples of Amun, where the children would "marry" Amun, and he would grant his favors to his followers (for a fee). The reduction of ritual prostitution – which was ostensibly respectable prostitution since it took place openly – in Egypt seemed to be the reason why the eroticism is hinted at symbolically in wall paintings and sculptures, while it is blatant and even crude in written material or papyri. A painting of a man smelling a lotus flower has a clear sexual meaning on a papyrus that also features a line explaining the symbol: "…He smells her fragrant genitals…." It is no wonder that while the paintings may be schematic and repetitive, the Egyptian language is replete with sexual expressions; every sexual organ or action has dozens of words for it.

The man is the dominant one in the sexual world that is reflected in Egyptian erotica. The beginning of creation was the man's act of masturbation, as if to say that it was possible to "do the work" without a woman (even though in other versions, the masturbating god's hand turns into a woman, and the female priests who serve Amun-Re are called "the hands of the god"). In addition, as the process of creation progresses, intercourse between a man and a woman becomes more central, both in the erotica and in the fertility rites and customs.

As early as 3,000 years ago, Egyptian literature attributed a lot of importance to love – or romance, as we define it – as something that enhanced sexual pleasure and increased fertility. Together with the emphasis on love as a basis for sexual relations, we find countless references to acts of adultery. The men in Deir el-Medina would go off to work in the Valley of the Kings for ten days, at the end of which they would return home for three days' vacation. Those ten days, during which the women remained alone at home, were called "the merry days of harlotry". In documents that were found at the site, including court lists, there were hundreds of cases in which women were accused of committing adultery while their husbands were away from home. A

German researcher remarked half seriously and half cynically: "…It seems that something in the physical or mental structure of the women of Egypt prevented them from closing their legs for more than a few hours at a time… Luckily for them, their husbands had not the bright idea of inventing chastity belts…" (taken from A. Karsani's book, 1908).

In the literary descriptions, we find lyrical descriptions that utilize symbols such as "He holds the spear in his hand", or "He plays the harp that is on her body", "She grasps the flute", "Heaven and earth met", and so on, alongside descriptions that border on pornography: "I inserted my finger and tasted her wetness", "With one hand, she holds her vagina and with the other she places the phallus [of the bull] inside her", and so on. The most explicit descriptions appear in the books of dream interpretation, where real sexual fantasies can be found.

In various sources, we learn about Egyptian men and women's copulatory customs with animals. We know for sure that there were religious rituals in which women copulated with he-goats and bulls in public. Similar uses of donkeys, horses, monkeys and crocodiles are also mentioned. Men preferred cows, sheep and she-goats, even though a female crocodile is mentioned.

Male homosexuality was accepted (particularly during the Greek era) and well known, thanks to the adventures of Seth with Horus. Lesbianism is also mentioned in several places, but to a lesser extent. Many researchers have remarked that because of the similarity between male and female figures in ancient Egyptian painting, it is sometimes difficult to differentiate between a man embracing a woman, a man embracing a man, or a woman embracing a woman. In paintings or sculptures of sexual acts, it is sometimes difficult to make out if the act is being performed in the "usual" way or orally.

In any event, it can be asserted that homosexuality was not a moral act, nor was it a legal one during certain periods. Adultery was considered to be a sin (unless it was committed by the gods, the royal

family or the priests and nobles), but it was widespread. Polygamy was not accepted, but it existed, and spells and amulets for improving one's sex life were the "hottest" items in Egypt. Medications whose aim was to cure impotence, strengthen erections, arouse passion or "cause a woman not to think of another man" were common. (The leaves and seeds of the acacia were the most popular remedy for phallus-related problems.) All of this is reflected in Egyptian erotica.

In conclusion, here is a small piece of advice we have learned over the years, in the style of an Egyptian poem (from the New Kingdom):

Take a handful of acacia seeds
Mix them in a saucer of honey
Anoint your erect member nine times
And take particular care with its smooth head.
And when this anointed member enters
The vagina of a servant girl or a king's daughter
She will be faithful to the owner of the member
Whether he is her husband or whether he is a slave in the field...

Contraceptive Methods in Ancient Egypt

In ancient Egypt, a connection was made between the semen that was ejaculated by the man during intercourse and the woman's pregnancy, and they also knew that the semen must reach the womb in order to impregnate the woman. In order to prevent pregnancy, various contraceptive methods were used, with the aim of preventing the semen from reaching the womb.

1. In order to prevent the semen from reaching the womb, the Egyptians adopted various methods of "blocking the passage" – Egyptian women would push pieces of cotton into their vaginas, and there are papyri that tell about a special servant whose function it was to take the piece of fabric out after intercourse (with tongs) and to burn it in the yard of the house. The Kahun papyrus mentions various methods by means of which the passage of the semen can be blocked – methods that also serve as "enemies of the semen" (spermicides): a mixture of crocodile dung and auti (a powder that is produced from the stems of a plant that resembles the rubber tree,) shaped into a candle shape and inserted into the vagina before intercourse; or a mixture of honey and natron; or a ball of "rubber" from the auti plant that can be washed after use and used again. Another papyrus, called the Ebers papyrus, suggests a piece of linen fabric soaked in honey and acacia tips. It is important to stress that among the Egyptian woman's makeup and ornaments (brushes, combs, mirrors and so on), we also find long tongs whose function was to push the pieces of fabric high up into the vagina.

In a Sanskrit text from the fifth century BC, it is written: "Egyptian women of pleasure are used to men ejaculating in their mouths, for that is the custom of Egypt – the first crop [the semen] is destroyed. And they tell that [in Egypt], many are the men who service themselves [masturbate] before entering the gates of the "house" [the whorehouse but also a name for the female genitalia]".

6. In a Greek text from the third century AD, there is a fine distinction regarding Egyptian sexuality: "They frolic with girls who do not yet have pubic hair [that is, girls who have not yet started menstruating] and act with them as if they are [married] women, while they act meticulously with their wives, they give them their semen sparingly, and always prefer the maidservant to the lady of the house. And this is what the Jews who live there [in Egypt, and the reference is to the city of Alexandria, about one-third of whose inhabitants were Jews] have also learned from them, to differentiate [between a girl and a woman] by the pubic hairs."

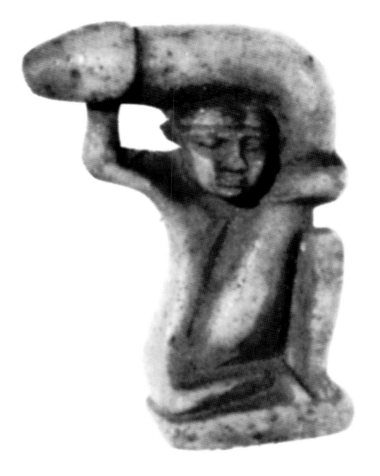

... Concerning Egypt itself I shall extend my remarks to a great length, because there is no country that possesses so many wonders, nor any that has such a number of works which defy description. Not only is the climate different from that of the rest of the world, and the rivers unlike any other rivers, but the people also, in most of their manners and customs, exactly reverse the common practice of mankind. The women attend the markets and trade, while the men sit at home at the loom; and here, while the rest of the world works the woof up the warp, the Egyptians work it down; the women likewise carry burthens upon their shoulders, while the men carry them upon their heads. They eat their food out of doors in the streets, but retire for private purposes to their houses, giving as a reason that what is unseemly, but necessary, ought to be done in secret, but what has nothing unseemly about it, should be done openly. A woman cannot serve the priestly office, either for god or goddess, but men are priests to both; sons need not support their parents unless they choose, but daughters must, whether they choose or no.

... In other countries the priests have long hair, in Egypt their heads are shaven; elsewhere it is customary, in mourning, for near relations to cut their hair close: the Egyptians, who wear no hair at any other time, when they lose a relative, let their beards and the hair of their heads grow long. All other men pass their lives separate from animals, the Egyptians have animals always living with them; others make barley and wheat their food; it is a disgrace to do so in Egypt, where the grain they live on is spelt, which some call zea. Dough they knead with their feet; but they mix mud, and even take up dirt, with their hands. They are the only people in the world- they at least, and such as have learnt the practice from them- who use circumcision. Their men wear two garments apiece, their women but one. They put on the rings and fasten the ropes to sails inside; others put them outside. When they write or calculate, instead of going, like the Greeks, from left to right, they move their hand from right to left; and they insist, notwithstanding, that it is they who go to the right, and the Greeks who go to the left. They have two quite different kinds of writing, one of which is called sacred, the other common.

... To Bacchus, on the eve of his feast, every Egyptian sacrifices a hog before the door of his house, which is then given back to the swineherd by whom it was furnished, and by him carried away. In other respects the festival is celebrated almost exactly as Bacchic festivals are in Greece, excepting that the Egyptians have no choral dances. They also use instead of phalli another invention, consisting of images a cubit high, pulled by strings, which the women carry round to the villages. A piper goes in front, and the women follow, singing hymns in honour of Bacchus. They give a religious reason for the peculiarities of the image.

... The Egyptians first made it a point of religion to have no converse with women in the sacred places, and not to enter them without washing, after such converse. Almost all other nations, except the Greeks and the Egyptians, act differently, regarding man as in this matter under no other law than the brutes. Many animals, they say, and various kinds of birds, may be seen to couple in the temples and the sacred precincts, which would certainly not happen if the gods were displeased at it. Such are the arguments by which they defend their practice, but I nevertheless can by no means approve of it. In these points the Egyptians are specially careful, as they are indeed in everything which concerns their sacred edifices.

The History of Herodotus. Written 440 Bc. Translated by George Rawlinson.

The Greek, Theodosius, who lived in the fourth century AD, tells us a strange story. He recounts:

When the great tomb was built, the wife of the governor of Upper [Egypt] feared for his life, for she had dreamed the same dream three times: As soon as the last stone was laid, her husband [the governor] would die immediately. And since she was full of plots, she sent her maidservants and her maidens to the stonecutters, and they pleasured them so much when night fell that they did not have the strength to go out to work in the morning. And when the building [foreman] saw this, he ordered that any stonecutter who was caught indoors at first light to be put to death. And the stonecutters would go out to work [without sleep] and stumble. And when he saw this, the foreman placed two Libyan women [at the gate of the camp], unequalled in their beauty, naked, and the two greeted every [stonecutter] with their singing and dancing. And since they were stonecutters, their groins were visible to everyone [since they wore a short garment that was open in front]. And the [guard] would whip the flaccid ones and give a coin to the erect ones. [In other words, he would whip flaccid penises that did not "come to life" at the sight of the dancers, on the assumption that they had been satisfied by the governor's wife's emissaries during the night, and he would give a reward to "the erect ones" on the assumption that they had saved their strength and slept the sleep of the just.] And the [last] stone was laid in its time. And eight days later, the governor died…

That is a strange story that does not seem to be based on a reliable source. However, in Africa, among tribes who wander around naked, we find women whose role is to "preserve the morals": In some of the tribes, the women use a branch to beat any erection that is visible in public… And in some of the tribes, the women beat any penis that does not show signs of an erection (on the assumption that it was involved in some form of adultery or other).

In the papyrus that is known as the Tanis Papyrus or the "Prohibition Papyrus" (because it mentions customs or taboos that were widespread in various places or at various times), some of the limitations are linked to sexual customs, for instance:

On a certain date, adultery is prohibited both for men and for women.

On another date, intercourse with prostitutes – male and female – is prohibited throughout the kingdom.

It is forbidden for a man to "play" with a young girl opposite the entrance of a temple[1].

In Upper Egypt, a woman is not allowed to ride a horse or a donkey without covering her pubic region.

On a certain date, it is forbidden to copulate with prostitutes (of either sex) or drink from a cup from which a prostitute has drunk.

In daylight[2], it is forbidden to copulate (even inside the house) in a position in which the man's bottom faces[3]...

1. Young girls would walk around naked until the onset of menstruation, and sexual relations with them were not prohibited. It seems that the only prohibition was on full vaginal penetration by the penis, and the circumcision line was the limit. The Egyptians related to these relations as a "game" and not as sex.
2. In the eye of Horus, the sun god.
3. probably the temple, but it could also be deciphered as "the holy river".

"The Egyptian Art"

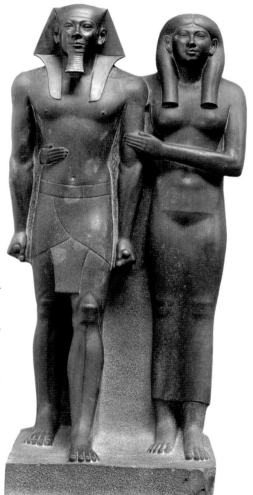

Many sources for understanding the erotica of ancient Egypt were found in the writings and inscriptions that originated in Pataliputra, a city in India that became famous because of two people: Alexander the Great, who arrived in Pataliputra during his the course of his conquests, and halted his campaign there, and a Brahman by the name of Vatsyayana, who lived in the city in the fourth century AD and gave the world the famous Kama Sutra.

The city of Pataliputra was situated on the River Ganges, between Calcutta and Benares, and was a port city, with an excellent port and "hundreds of taverns, inns and whorehouses spread throughout its streets," according to a first-century traveler. The place is known as Patna today.

Pataliputra was known in the India of thousands of years ago as a "city of pleasure." Men arrived there from all over India not in order to trade, but to savor the arts of love. Prostitutes flocked there from all over the known world because in Pataliputra, their fee was several times higher than in other places. It is no wonder that the author of the Kama Sutra

derived his inspiration from that was going on literally under his nose. An eighth-century traveler wrote: "…And when the ship reached the city [Pataliputra], the sailors hurried to the little bungalows covered with curtains… and some of them left their entire wages with the whores, and did not have a coin left for a drink… because pleasures like those could not be had in my country…"

Let's get back to Alexander the Great. When he reached the city and halted his armies, his warriors pounced on the city and its pleasures. A Greek text recounts the story of one of the regimental commanders who could not control his men and apologized: "…They have great lust for the women of the city, and they shirk their guard duty in order to go to the Egyptian women…"

And here Alexander the Great asks: "Who are they, the Egyptian women?"

And the commander answers: "…These women were taught the Egyptian customs, and no man can resist them. They attract soldiers to [the canopy] as they wish, and they are so wondrous in their passion that even the toughest of my soldiers leaves them his fortune and his manhood…"

A brothel-keeper from the sixth century BC who left detailed inventory lists behind him, teaches us about the value of these Egyptian women or prostitutes. The trader, Rajo, keeps his books, and the "unit of currency" is Sia – a unit of currency that is actually "a local girl who has no [erotic] talents yet and is his private possession." Rajo has in his possession:

"Three white-skinned Egyptian women each worth 18 Sia... Two black-skinned Egyptian women [Nubians], each worth 11 Sia, and a blind Egyptian dancer who is worth 14 Sia. And also... two [local] girls who were taught the Egyptian way, each worth eight Sia."

Rajo elaborates on the history of the eight-year-old child he purchased from her father and gave over to the "Egyptian" woman. He mentions that "within four years, she was so experienced in the Egyptian art that I exchanged her for three beautiful little girls, a servant [from the North] and seven woven fabrics." Even though it is obvious that "the Egyptian art" is linked to sex, we do not know for sure what it was.

G. Butler, who sought early (pre-fourth century AD) texts in Pataliputra, since they served as the basis for the Kama Sutra, wrote a detailed passage about Egypt. According to him, he bought the inscription written in Sanskrit on paper in 1890, but the copier showed him an ancient scroll of wooden tablets, also written in Sanskrit, from which he had (apparently) "copied" or "rewritten" the paper he had sold to Butler. Butler gave the passage to his assistant for translation, and the latter translated it into... German, which was his mother tongue. During the long journey back to Manchester, his home town, Butler lost some of his papers, but the German translation remained, and was published as a thin brochure in a private edition in 1898 (a few lines from this brochure also appear in Butler's travel book, which was published in 1903 in a private edition). We managed to find four pages from the brochure (which apparently comprised 12 pages), each one printed on one side of the page.

One last comment: G. Butler does not get a very high grade when it comes to scientific credibility. Most of the researchers ignore him completely, and his works were not published by prestigious university publishing houses. However, when we examine his surviving writings, we can find many parallels to his findings in other reliable sources.

Butler quoted sources that attested to the fact that the Kama Sutra, for instance, contained several chapters about the art of homosexual love for men and women. Richard Burton, who translated the Kama Sutra into English, distorted and censored these chapters, as we now know, but in his time, his translation was considered to be the best source of the Kama Sutra. Butler was accused of fraud, and articles denouncing him were published in the English press. Today, every full translation of the Kama Sutra contains those chapters on homosexual love between men (even though one chapter about lesbian love that Butler referred to has not been published to this day).

Butler left us only a few findings that are linked to ancient Egypt, but as you will see, every finding has the support and verification of other sources.

Here is the translation of the passages in German that are relevant to our book:

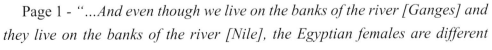

Page 1 - *"...And even though we live on the banks of the river [Ganges] and they live on the banks of the river [Nile], the Egyptian females are different than the [females] of our country. For they [the Egyptian women] are permitted to any man from birth until they become women, and are forbidden to men after [they begin menstruating], and learn from birth to feel the head of the member [the penis]*[1] *in their vaginas, and [our women] are forbidden to any man until they become women, and are permitted only to their husbands...*

"From birth, they [the Egyptian women] are permitted to any man, whether they be members of the household, domestic slaves or strangers. And being permitted, they walk around naked, for fear that someone [of the men] will tear their clothes, and their clothes are open in front and expose their private parts[2]. And the men take them and rub themselves against their private parts, and insert their members to [a depth of] three fingers inside them, and holding the member, they move it like the rising and setting of the sun, there and back, in a semicircle[3], and when they reach their climax, they spill their semen to the ground, and even though they [the Egyptians] are like [horses?][4], the [Egyptian woman] will not have difficulty accepting them [when she is mature] because...

"And as for the women, when their breasts become rounded and their private parts are covered [with hair], the girls go to the [wise] woman, and she examines their vaginas and their blood[5]... for the virgin girl has no advantage over the girl who has had intercourse with a man[6]..."

Page 2 - *"...And it is their [the Egyptians'] custom to tie naked women, slaves and [free] girls alike, to the chariot, and they pull the chariot around and around, [and the man] driving the chariot copulates*

with one after another[7]... and that is how the rich and the royal family behave..."

Page 3 - *"...that lives in the waters of the river [Nile]. And they [the Egyptians] do not fear it, but rather think that the crocodile is a holy beast, and their men and women copulate with it in full view of everyone, in the belief that blessings of good things will be the result. And they believe that the dolphins that live in the waters of the sea, like the crocodiles, also copulate like people[8], and they go out to the sea..."*

Page 4 - [The extract describes a kind of sex contest between various prostitutes, and most of it is full of errors – either because of the source was full of errors or because of the morals of the person who translated it into German.]

"... And she [an Indian girl from "The Slope of the River"] lay down with on her back and lifted her legs in the air, and two burning oil lamps were placed on the soles [of her feet], and that is how she received the men, one after the other, as much as they wanted... and the oil did not spill, and the flame did not tremble[9]..."

"And when the Egyptian woman saw this, she lay on her back and lifted her legs in the air like the Indian [girl], and a burning piece of charcoal was placed on her feet, and that is how she received the men, one after the other... and there was no mark on her skin[10]..."

1 In Egypt, "the head of the penis" is defined as the ring of circumcision. Jewish texts that discuss "copulation" in detail determine that the insertion of the head of the penis is not defined as copulation. "Copulation in the Egyptian way [insertion of the head of the penis] is not copulation!"

2 Egyptian paintings feature naked girls (when the women are clothed), but the reason, "for fear that someone will tear their clothes," is not logical.

3 An Egyptian text contains an extract from a love song: "My love will come inside me and will move like the sun [god]… / and as he goes back and forth / both I and he will have pleasure…"

4 The image of the Egyptians having the potency of horses appears in the Bible as well (Ezekiel 23).

5 In order to discern whether the blood was menstrual blood, the blood from a ruptured hymen or from some other injury.

6 In the opinion of the German translator, this is an addendum to the original text.

7 This sexual entertainment, which features in ancient Greek and Latin sources as well, is mentioned in the Bible in the Song of Songs, 1:9: "I have compared thee, O my love, to a company of horses in Pharaoh's chariots."

8 The crocodiles and the dolphins indeed copulate "like human beings", face to face, and the Egyptians knew this and considered these creatures special for that reason. Evidence for this appears in Jewish writings as well. However, it must be remembered that the "normative" sexual position in Egypt was the "grinding" position, which is parallel to the "cow position" in India.

9 Positions of this type appear in the Kama Sutra and in other Indian writings. The Indians stress the woman's ability to satisfy men with the positions of her body – even when her legs are as stiff as those of a statue. This does not refer to a situation in which the entire woman is frozen like a statue.

10 It would seem that there is an error here. There is a sexual position called "the ball in the air" in which the woman lies on her back and bounces a ball from one foot to the other, like in a juggling performance. There is a worn clay relief (which is therefore difficult to photograph) that shows a temple prostitute lying on her back on a stone, juggling three balls with her feet, a man between her thighs. Apparently, the original text spoke bout an Egyptian juggling with a burning piece of charcoal (instead of a ball) during her sexual acts.

Homosexuality

Homosexuality – between men and especially between women – was expunged from most of the ancient Egyptian texts and works of art. Many researchers claimed that homosexuality hardly existed in Egypt, and a well-known scholar called Frank Fortis claimed in a lecture in 1950 that "sexual pleasures were available to every Egyptian of a certain status and upward… Sexual intercourse was performed openly, incest was acceptable, and during certain periods, men could have almost full intercourse with little girls… It is no wonder that in a society like that, the Egyptians did not need homosexual relations at all in order to satisfy their sexual lust…" A day after that lecture, Mr. Frank Fortis gave another one about sexual customs in Egypt that were linked to sex with animals, and he uttered the sentence, "Deprivation and sexual inhibitions, cultural limitations, forced the Egyptians to find satisfaction with animals of various kinds. Men and women alike indulged in these customs." So it is difficult to say that his lectures were particularly consistent.

Even so, in one of the most reliable texts, which appears in the Prisse Papyrus (found in an archive in the Bibliothéque Nationale in Paris) from the Middle Kingdom era and is backed up by Papyrus 10509 from the British Museum, a specific mention of homosexuality and the pleasures of single-sex intercourse appears in passage 32: *"Do not copulate with a woman-boy, even if he believes that what is contrary[1] is what he likes, and only that will satisfy his passion. Do not spend the night with him doing what is contrary so as to satisfy his urges!"*

1. To human nature, that is, heterosexual relations.

Ancient Egyptian Gay God

During the pharoanic period Seth was god of male homosexuality. He was depitcted in different forms - sometimes as a gender-variant male and sometimes as a red or white-skinned man with the head of a dog, the body of a greyhound and a long forked tail.

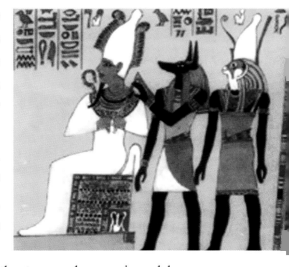

Originally he was, according to legend, given Upper Egypt to rule while his handsome nephew Horus ruled over Lower Egypt. After the reunification the two gods were frequently depicted as a couple with the symbol of unity between them. There is also a clear implication of a homosexual relationship and in one myth Seth "gives birth" to Horus' child.

Another legend has it that Seth tried to rape Horus, and that for several days that two battled, transformed into hippopotami in the Nile. Seth tore out Horus' eye but Horus ripped off Seth's penis. Eventually, however, after the intervention of Thoth, the monkey-like god of wisdom, the two god's were reconciled.

The legendary sexual struggle and eventual reconciliation between the two gods are viewed by historians as allegories for the fighting between upper and lower Egypt which finally led to the country unifying around 3000BC.

The Turin Papyrus: The Illustrated Egyptian Sex Guide

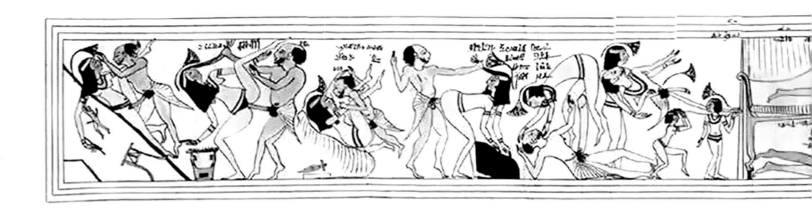

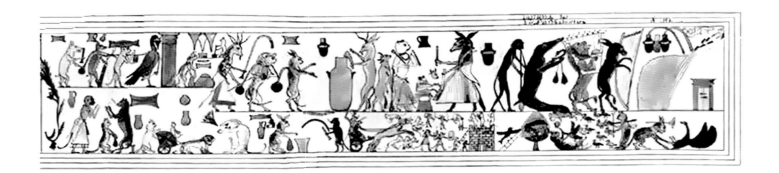

As far as we know, the Turin Papyrus is the only surviving erotic papyrus from the ancient Egyptian era. This is a papyrus that was badly preserved, and many parts of it are blurred or torn. The

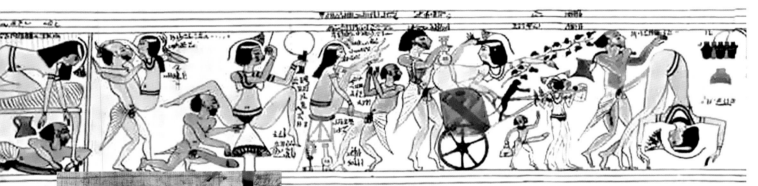

papyrus is about eight inches wide and apparently about one hundred inches long. It is divided into two parts or topics. The first and larger part contains a row of erotic drawings about seventy inches long. The characters are divided into various groups – 11 or 12, according to different researchers. The number 12 is very important in ancient Egypt, and it is frequently linked to sexual or medical texts or texts dealing with dream interpretation.

The second part of the papyrus contains mainly drawings of animals, sometimes defined as satirical drawings, and a large part of it is missing. There is a line drawn between the two parts, and it seems that the drawings of the animals were the first to be drawn in the papyrus. We do not have the faintest idea why the two topics were connected in one scroll. All the attempts to ascribe an erotic meaning to the animal drawings are unfounded. (Researchers such as P. Larka claimed that the drawings represent the same animals as those with which the Egyptians had sex. In the margins of the papyrus, a sex scene between a cat and a goose can be seen.)

The size of the papyrus is a key factor in determining its date – the 12th or 13th century BC. The papyrus was found, along with other papyri, at Deir el Medine near Thebes in the part of the kingdom that is known as Upper Egypt. It was found in the 19th century, and since its initial discovery it has been severely damaged. (Most of the reconstructions today rely on sketches from the 19th century, which contain details that are not visible in the papyrus today.) The drawings in the papyrus were outlined in black ink, and the colors used by the artist were red, yellow and green. In Egyptian mysticism, these are sexual colors. One could assume that the erotic part of the papyrus was drawn from right to left, like the direction of the writing, but large parts of it indicate that it went in the opposite direction – from left to right. The brown background we see on the papyrus today is the result of damage caused by the weather (which also blurred and erased the colors in the papyrus). The interesting

part of the drawing itself is the absence of a division of the papyrus, or markings that appear in other papyruses – this attests to the fact that the artist was sure of himself, drew quickly without erasures, and apparently produced papyri of this type in great quantities, depicting the same characters and acts over and over again. For many years, this papyrus was viewed as a pornographic-satirical scroll, and researchers tended to ignore it. Later, they began to examine it as a religious expression – graphic descriptions of human acts (also performed by animals) that imitate the acts of the gods. It seems to us that the recent widespread tendency – namely, to view the Turin Papyrus as a sex guide – is the most suitable, apparently because it is the only remnant we have of ancient Egyptian love scrolls, which were a part of the sex education of Egyptian nobles, just as the Kama Sutra was used by the nobles of India, or the Shunga was used by the nobles of Japan.

In the past, there were two widespread approaches to understanding the papyrus: The first viewed the papyrus as an illustrative description of the adventures of a priest (probably of Amun) with a whore or whores from Thebes, a city that was know for its brothels. There are also researchers who related to the papyrus as a "self-fulfilling prophecy". According to the custom in ancient Egypt, if a person wanted a certain thing, for instance, a new boat, he had to draw or sculpt a model of a boat and sleep with the model next to him in bed. When he dreamed about the boat seven consecutive times (a dozen times, according to others), he

would obtain it. The Turin Papyrus was "the boat" and the priest was trying to use it to fulfill his desires. The second approach viewed the papyrus as a description of the amorous adventures of a king or a governor who ruled in that place, similar to the numerous existing descriptions of battles and victories. It is worthwhile mentioning that from the artistic point of view, the papyrus is similar to other paintings and stone reliefs from the same period, and it is reasonable to assume that it was not an illegal or forbidden drawing.

A more meticulous examination of the papyrus reveals that the first two approaches do not make sense. The men who appear in the drawings differ from one another (especially in their hair and beards), and they are wearing the clothes of the lower classes. Opinions differ with regard to the women. Some people considered the images to be those of one woman who used different wigs and accessories to alter her appearance (someone also claimed that this was the advertising leaflet of a local prostitute), while others viewed them as different women. The women are wearing the feminine accessories of the time – wigs, belts, jewels – and use cosmetics (lipstick).

It is worth mentioning that although we can identify a chariot, the entire spectacle takes place inside a house or in the enclosed garden of a house. We see a bed, pillows, a stool, musical instruments including a sistrum (a musical instrument dedicated to Hathor, the goddess of love), and drinking vessels – completely ordinary accessories during the act of love – in addition to the chariot and the unusual accessories. These characteristics strengthen the claims that the papyrus describes an orgy in an ancient Egyptian brothel.

The papyrus itself is not mentioned in the ancient texts, but if we take the scenes described in it and try to describe them in words, we find numerous parallels with Egyptian literature. Another source for assessing the papyrus is the work of the Arab writer known by the name of Ibn Kaldoni the Libyan, who

probably lived in the eighth century AD. He quotes a Roman writer who mentions a Greek writer (probably from the second century BC) who reports on the Egyptians' customs regarding sexual intercourse. Eight of the descriptions that appear there as "sexual positions" are described in the Turin Papyrus, so that it is possible to assume that the Greek saw this papyrus or a similar one.

In the margins of the erotic descriptions, lines of writing have survived. Not all of them have been deciphered, however. This writing accompanies the drawings. It seems that additional lines of text were deleted. We can identify several names of gods and several erotic expressions: "My enormous phallus found the inside…", "To move like the sun in a chariot makes me feel good", "Don't be afraid of what I'm going to do to you", "Bring the loving phallus into me without me seeing [that is, from behind, from a place I can't see]", "You see – the whole phallus has entered me. I'm not ashamed [of my ability to contain it]", "My bed is empty…", "Oh, God!" Of course, this is not an exact scientific translation, but it gives us an idea of the nature of the captions that accompany the pictures. It is also clear that the scroll was meant mainly for men!

Now we will relate to the scenes depicted in the papyrus one by one, from right to left, and we will try to provide a more precise translation of the writing that appears next to each picture.

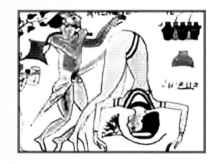

1. The position of Nut

Although most of this drawing is damaged, it can be reconstructed very precisely because it is possible to be accurate with regard to the position and outline of the bodies, and because, fortunately for us, there is a sketch from the 19th century that was made before the papyrus was damaged. The woman is imitating the position of the goddess Nut by bending forward with the man positioned behind her. Since the man is standing upright (except for slightly bent knees), the woman has to raise her bottom – a position that is almost impossible. Both the man and the woman are standing on tiptoe, and the woman supports herself on her fingertips on the floor. The woman's face and the jewels she is wearing attest to a woman of class and beauty. The man is equipped with a penis that is 40 percent as long as his entire body. In any event, it is over 25 inches long. His testicles are not in proportion to his penis. The man's face shows that he is a member of the lower classes. In his right hand, he is holding a rope that is attached to a sack slung over his left shoulder. His left hand is held above the woman's bottom, but does not touch it. The function of the sack is not clear, but the most logical assumption is that it serves to balance the pair, since the weight rests on the woman, and every movement of the man toward her is

liable to upset his balance and cause both of them to fall down. This mechanical explanation is also bolstered by the caption that says, "Release the bonds you placed on me…". It seems that in order to pull the woman into this position, the couple made use of a strap or a rope, as we see in the various pictures that adorn the sex guides in India and China. Various researchers perceive this position to be an anal one, but in fact it does not afford any possibility of anal penetration. Ibn Kaldoni mentions the "woman holding her ankles" position in which the woman bends forwards and holds her ankles with the man behind her. He mentions that one can make use of a belt in order to "tie" the woman up and make the position easier for her. The expression on the man's face attests to great concentration, and it seems as if his climax is near.

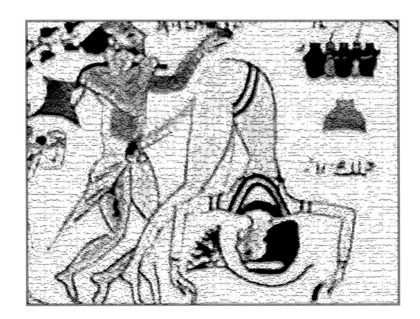

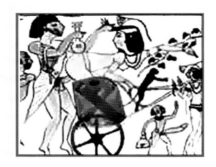

2. The king gallops to his pleasures

The second position is the one that gave the papyrus its title, "The Intercourse of Kings" as a result of the notion that it depicts the amorous adventures of a king or ruler. This is not the case. The most royal scene in the papyrus is the one that is described here, since chariots were unique to the rulers. On the other hand, the penis of the man in this scene is not particularly impressive in comparison to the rest of the phalluses (only about 15 inches), and it is not possible that in an erotic papyrus that describes a king, the latter's organ is smaller than that of the other figures in the papyrus. Thus, it is clear that this is a staged scene whose purpose is to present a situation "like that of a king".

The woman is standing in a typical Egyptian chariot, used mainly by warriors. She leans forward, making her bottom protrude, and bends her knees in order to align herself with the man's penis. The man is standing on his toes on the ground behind her. The picture is sometimes called "The goddess of love going out to battle" for that reason. The man holds the woman's wig as if holding reins. The woman's breasts are prominent. Her gaze is directed backwards, to the man, and they create eye contact. In her

right hand, the woman holds reins while her other hand leans on a plant whose shape is reminiscent of hearts – a plant that occurs frequently in erotic drawings. Two girls are harnessed to the reins, and, despite the fact that their genitals and breasts are bare, they do not appear "sexual". On the shaft stands a black monkey. The monkey symbolizes sexuality, and intercourse between women and monkeys was widespread in ancient Egypt. Beneath the shaft we see a "youth" or "dwarf" with an immense penis in relation to his height. The penis points at the two girls pulling the chariot, as if to say that he has to make do with an inexperienced girl rather than with an experienced woman. The youth carries a woman's cosmetic bag in his hand. On his arm hangs a sistrum. Although there is a sense of movement in the picture, and many have assumed that sexual intercourse takes place while the two harnessed girls move the chariot, this is not logical. It is far more logical that the girls are shaking the chariot up and down, thus achieving an effect of rocking. The outline of the man's face is crude in comparison with the portraits of other men.

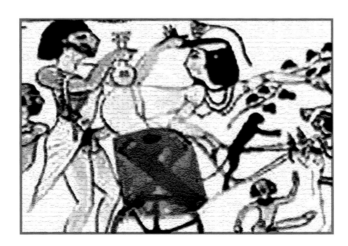

3. The woman who lifts her legs up to the sky

This is a position that was common in ancient cultures, and it is accompanied by a great deal of text, creating a link with the figures (the positions) around it. The woman is seated on a high chair and lifts her legs up so that her feet are above her head. This position requires considerable physical exertion. Beneath the chair we see a jar and a musical instrument, as in position number 2, and in addition, a container that evidently served as a place for keeping makeup. A lotus flower is drawn above the woman's head. Her left hand is stretched forward in order to draw the man's attention to her. Her right hand is aimed at his long penis inside her vagina. The man who is standing in front of her on tiptoe has an ugly face and is short (which increases the impression of his long penis). His testicles are quite big in comparison with other figures. He looks behind him (to the nearby chariot scene) with curiosity and lust.

This position was common in ancient cultures, and in ancient Egypt, there are a few stone etchings depicting it. In many cases, it is described as an initial "getting acquainted position" for a man and a woman.

The accompanying text is interesting. We will attempt to present it in a comprehensible way: "Thoth [the god of writing and art] saw how she managed by herself. She brings him to her depths like the others... I am trembling [with passion]..."

"I will give you pleasure the likes of which you've never experienced. Don't be afraid. And can I cause you evil? Push inwards and don't look backwards. Come to me from the front or from behind and your pleasure will increase... You have inserted a tremendous phallus into me... How will I be a decent woman after this rod has been stuck into me?"

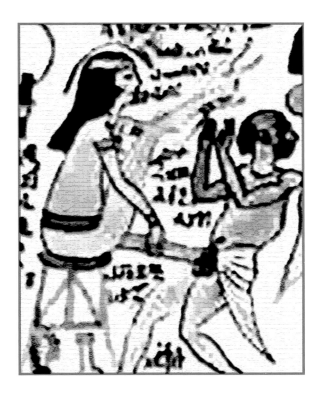

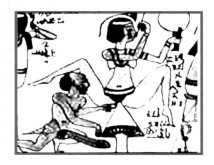

4. Isis gives her juice

This is a well-known drawing that has engendered countless interpretations and arguments. A naked woman sits with her legs apart and applies makeup with a brush and a mirror. Above her head there is a drawing of a lotus flower. The man kneels at her side, his eyes at the level of her genitals, and he stretches his right hand toward them, while his left hand pushes a totally unidentified vessel toward them. Is this a jar for administering a vaginal rinse? Is it an appliance for masturbation or for widening a narrow vaginal opening? Is it an instrument for collecting the juice that flows from an aroused vagina? The man shows off his long, hard, circumcised penis. A small amount of undecipherable text appears beside the picture.

In order to try to understand what the picture is trying to depict, we have to go to the classical Greek culture, and particularly to the Roman culture. We find sculptures and stone reliefs that depict a similar scene. One of the sculptures explicitly depicts Isis, and this is where the name in the title above is taken

from. We learn that women made use of that "jar" or "triangle" when they were alone or in the company of men or women, and in one case, there is also an explanatory text: "…she collects the blessing of the goddess of love". Most of the commentators describe the scenes as mutual masturbation, but it seems to us that the drawing has a meaning beyond that. Three thousand years ago, the Egyptians believed that the juice secreted by the women during arousal or intercourse had many medical properties, and this juice was also used in religious rituals. Figurines of gods were anointed with the juice that women offered as a sacrifice. In many medical books, women are advised to insert a finger into the vagina, and when the finger becomes wet, they are to put it in the patient's mouth (usually a child). This juice also possesses aphrodisiac properties, especially for men whose virility wanes after one sexual act.

In our opinion, this is the correct interpretation of this drawing in the Turin Papyrus. Furthermore, it seems that this activity was popular. The fact that it appears in this erotic papyrus alongside blatant sexual positions does not cause any amazement.

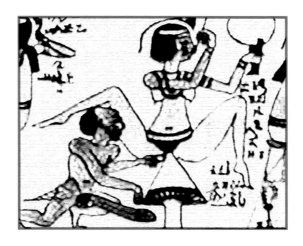

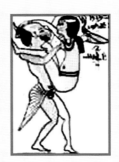

5. He carries her in his arms

This is a popular position that also appears in many stone reliefs and occurs in a similar style in all the ancient cultures. The man stands on tiptoe with his knees slightly bent – and holds the woman in the air. The fact that she is detached from the ground and suspended in the air (and from the man) is of great mystical-religious significance. The woman's legs are placed on the man's shoulders, and she supports herself with one hand on his body and the other over his head. Later on, she is supposed to lift both her arms into the air. The man squeezes the woman to him with one hand while his other hand is free to caress her. Although most of the "work" falls on the man, and only strong men can have intercourse in this position, the woman has to move her pelvis down and up (using her legs, which serve as anchors) – which requires a great deal of pliancy. This position appears in many descriptions or books that are connected to adultery, and for that reason it has sometimes been described as suitable for "quickies", when there is a danger that someone will appear and cut the act short.

There are commentators who stress the appearance of the man's face. His nose looks as if it has been cut off. The punishment of cutting off a nose was routinely inflicted on criminals in ancient Egypt.

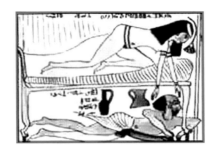

6. The game of seduction

The man lies on the floor, displaying his long, hard penis. Behind him, there are two jars. He lies on his stomach and does not look up, so that his back is facing the woman kneeling on the bed above him and trying to draw his attention to her. Above the woman's head is a lotus flower. We are not sure if she wants him to get out – or whether she is pleading with him to come on to the bed and have sex with her. The text describes a dialog that can be summarized as follows: "Come to my bed and fill me with your seed. I don't have much time and I'm full of desire." (It is also possible to read her words like this: "Go away from my bed… in which you left me drowning in your seed.") The man replies with a kind of self-advertisement: "I have a gigantic phallus, it will satisfy the passion of every woman…"

There seems to be a link between the next scene and the previous scene.

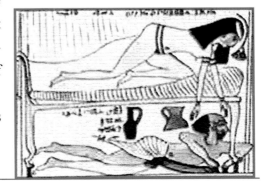

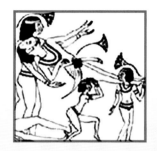

7. First aid

In the next picture, we see three girl-slaves carrying a man whose head is hanging backwards and whose big penis is limp and dangling. The direction of the group's movement is toward the bed on which the woman in scene number 6 is kneeling. (This is perhaps a reason to get rid of the man who is beneath her.) Another possibility is that the man does not feel well, or his penis let him down, and the girls are carrying him toward the bed and onwards, like a client whose allotted time with the woman has ended.

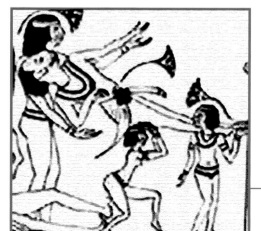

The papyrus is severely damaged at this point, but we are able to reconstruct it from a sketch done in the 19th century. The center of the entire picture is the gigantic phallus hanging limply and dangling down.

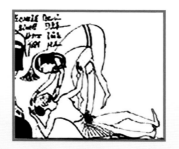

8. The "classic" Geb and Nut position

This is the best-known position in ancient Egypt, and represents the gods. The man lies on his back and guides the woman, who is above him, into the position of Nut (like the heavens above the earth) so that she is sitting upright on his erect penis at right angles to him. This position is called "the Egyptian position" in many places. Some people also call it "the Lilith position". (According to Hebrew sources, Lilith was Adam's first wife, and she demanded that he let her lie on top of him during intercourse. Adam refused and banished her.)

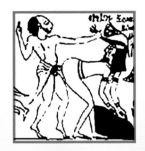

9. The cow position

This was a popular position. The woman bends forward and positions her bottom opposite the man's penis. He grasps her wig and also seems to grasp a rope attached to a sack on his shoulder for balancing his movements. It seems that there were more details on this part of the papyrus, but they were lost. In front of the woman, there is a cushion (green in the original) that she uses for support. This position was widespread in the ancient world.

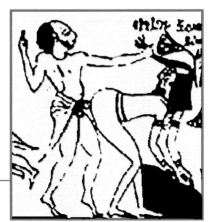

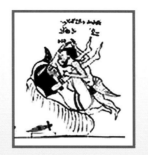

10. Face to face

This is an ordinary position, almost "missionary" in nature, although the fact that the woman lifts her legs – one on the man's shoulder and one in his armpit – upgrades the position. The woman lies on a mattress that fits her body, and the man, who is leaning on one knee, moves his body by means of his left leg. The picture was damaged and its reconstruction was carried out according to early sketches. The accompanying text is interesting. The woman says, "Take the place of the one who pulled out of me… and I'll thank you, sir, for your passion…"

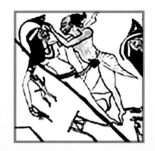

11. Oh God!

This was an acrobatic position that became very famous. First there was a heated dispute about the question of whether the woman is standing on one leg or lying on her back and spreading her legs. To this day, it looks as if the woman's right foot is flat on the floor, and in our opinion, it is obvious that she is standing on one leg and lifting the other one into the air. Her legs are spread wide open. The man balances her body by holding her wig. There is a lotus flower above the woman's head. A harp is placed beside her, and for this reason, this position was described as "Dancer-player during intercourse". The text expresses the picture better. It uses an expression that can be translated as "Oh God!" or a big "Yessss!"

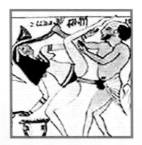

12. Osiris comes back to life

The story of Osiris and Isis has been presented elsewhere, and here, in the 12th position, we return to it. The figure that appears here is the same woman who appeared in position number 3, the brush still in her hand, but now it is pointing downward, and the chair on which she was sitting has fallen to the ground. This time, she is lying on a plank that is positioned at a 45-degree angle – just as Osiris lay after Isis found his organs. One of her legs is close to the plank and the other is placed on the man's shoulder.

According to the little that remains of the original papyrus, it seems as if the man who is with her here is not the man who appeared with her in position number 3 (even though some people claim that he is). There is an air of gentleness and tranquillity in this position. It is clear that the main difference between this position and the original Osiris-Isis position lies in the fact that here the woman is lying on her back while he is the more sexually active one. Attached the woman's arm is a small image of man with a large penis. We are unable to explain the role of this image in the papyrus.

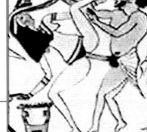

The Lecherous Gods

Ancient Egyptian sexology is closely linked to religion. The gods are described as sexual creatures with lusts and passions, who engaged in love, sex and adultery on a regular basis. In papyri, texts, travelers' reports and art, we see that the Egyptians revered the gods' sexual activity and tried to imitate it in every possible way. If we collect the "official" texts – that is, those whose originality and translation have been accepted by the various researchers – we find a rich, extensive range of sexual activities. Other texts exploited the ancient Egyptian gods as a pretext for writing pornographic literature. One of the examples from the relatively modern era was the torrent of "Egyptian" erotica that swamped France following the findings of the scientific delegation Napoleon sent to Egypt, which placed ancient Egypt at the top of the scale of interest. In the Louvre, there are dozens (perhaps hundreds) of so-called "discoveries" of erotic texts that were discovered or translated from an unknown source in the 19th century, and posed as original ancient Egyptian works. In one of them, Osiris, using a hot-air balloon, lands in the middle of

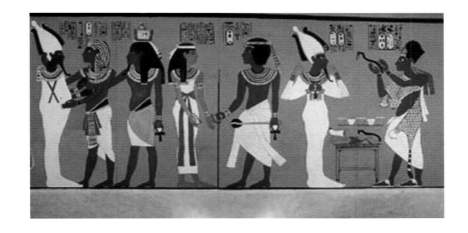

a harem populated by scores of exquisite women. (Some scientist or other restored Osiris' missing penis to him.) This sentence sums up the three first pages of the book. The other 174 pages are dedicated to Osiris' extensive activities with the women. Of course, this is an extreme example. Far more important is the fact that anyone who showed any interest in ancient Egypt – whether they were scientists or amateurs – considered the sex- and pleasure-loving gods and goddesses to be an inseparable part of the general Egyptian picture.

Egyptian mythology places the sun god, Atum [or Amun-Ra], at the top of the pyramid of the gods. He created himself from nothingness in a non-sexual act, and immediately masturbated and created two gods, Shu and Tefenet. These two united and brought two gods who were closer to human beings into the world – Nut, the goddess of the sky, and Geb, the god of the earth. Immediately, those two (brother and sister, in case you didn't notice) engaged in passionate sex, with Nut taking the initiative, while Geb lay and waited to be serviced. It is important to understand that the mythology of the Egyptian gods

developed in a period in which there were two accepted positions for intercourse among human beings: (1) the woman bending forward or kneeling and the man behind her – a position that enabled the man to be ready for battle – and (2) the man above the woman. The Nut-Geb position constitutes a breakthrough in the sexological culture of the ancient world.

Nut and Geb were the happy parents of Isis, Osiris, Seth and Nephthys. Up till then, all sexual relations had taken place among the happy family of the gods. Osiris and Isis continued the tradition and gave birth to Horus, but we also find the buds of sexual relations with other gods outside of the family, and with human beings. Various papyri dating from 3,500-4,000 years ago provide us with a glimpse into the rich sex life of the family of gods:

"On the edge of the pool lay the great god, the sun god, Amun-Ra, the sun god lay on his back, next to the pool of water he lay, alone, and only had the lotus flowers for company. A light breeze blew, a breeze blew and carried a fragrant smell to the sun god, a breeze blew and carried a smell that filled the god with lust and sent his member toward Nut [the sky]. Following the smell, the goddess arrived, the most beautiful of all the goddesses, the sun god's right hand[1]. Her name was Hathor. Hathor came before the god, Hathor stopped in front of the sun god, Hathor stood in front of her father, Hathor stood in front of the ruler of the world. She revealed her nakedness to the creator of the world, she opened up her nakedness to the god, she brought her wet vagina to the god's face, and her smell was like the smell of the lotus flower in bloom. The god smiled at her open nakedness[2], the god smiled at his daughter…and that entire day Hathor rode[3] on her father's member, until the evening shadows fell…The god's right hand was Hathor, the god's favorite nakedness was Hathor… Like a waterfall he filled her nakedness with his seed…"

However, Isis is the one who provides most of the interest at this stage of the chronology of the gods – Diodorus implies that she was married to Osiris (her brother), and had sexual relations with another

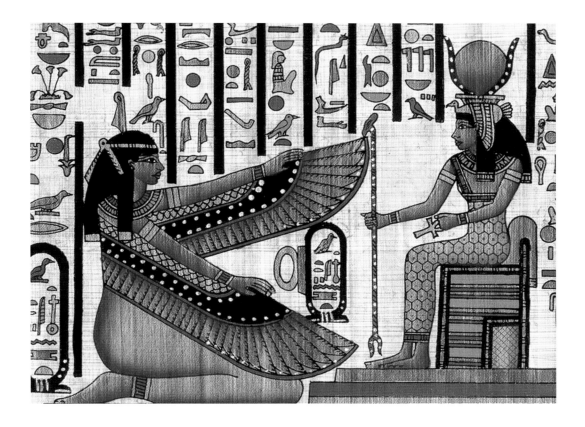

brother, Seth, and with her son, Horus. Other sources talk about the warm relationship between Isis and Geb, her father, and it is clear that the sun god himself, who was known for his vigorous activity that did not discriminate against any goddess, also buried his member in her curves.

It should be mentioned that other sources claim that there was a power struggle between Seth and

Horus, both of whom accepted Osiris' superiority and struggled for power after him. Seth tried to woo Isis in order to increase his chances, but she rejected him.

"The god Seth saw her approaching from afar, even though she was not wearing her form, but rather the form of a young girl whose beauty was unequalled, more beautiful than any human woman in the entire world, and immediately his heart was overcome by love for her. He rose at once and offered the sacrifice of bread[4], he wanted to conquer the most beautiful of women, and not one of his brothers[5] [the gods] saw the beauty. When she saw him approaching, she [Isis] hid behind the trees.

Seth shouted: 'Where are you, my beauty? I have come here to take you!'

Isis replied: 'My lord, my most merciful lord. I was a herdsman's wife, and I gave him a son. But my husband died and my son herds the cattle and the livestock after him. And one day a stranger arrived at the cattle pen and said

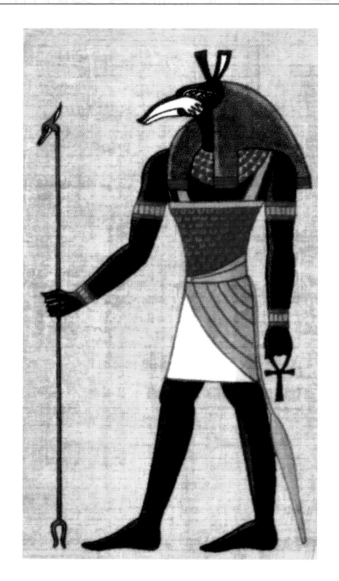

to my son: I will break a stick over your head, I will give you a kick in the backside, and I will take your livestock and cattle for myself! That's what he said. My request is for you to beat him[6].'

Seth said: 'Who will allow a stranger to take the livestock and the cattle when the son of the father is alive!'"

Here Isis revealed her true identity and accused Seth of wanting to steal her son Horus' inheritance. Clearly, other sources do not spare the sexual descriptions, which tell how Isis first granted her favors [in the guise of a human woman] to Seth, and only afterwards did she ask him the trick question. In one of the later sources, Seth answered her [after she revealed herself]: "Lie with me for a few more days, and [Horus] will be my son," in other words: You lie with many men, therefore the [legal, not biological] father of your son is the one you lie with the most[7].

Even so, Seth wanted to make love with Isis, because intercourse with her would bring him nearer to his goal – to be Osiris' successor. Seth, therefore, resorted to a stratagem that no Egyptian goddess or woman could resist: he transformed himself into an extremely potent bull! Could an Egyptian goddess resist such a powerful temptation? Only Isis could! Despite the lust the potent bull aroused in her ["...my belly hurts from so much desire..."], she transformed herself into the mythological figure of a bitch with a long, sharp sword-tail and with razor-sharp claws. In this form, she escaped from the bull, Seth, who could not mount her and copulate with her [because her sword tail would kill him]. In his fury and lust, he ejaculated his semen on the ground, and Isis taunted him: "You miserable bull, could you only find the dry earth as a partner?" Incidentally, the story goes on to say that a watermelon grew in the spot where Seth's semen had fallen, and that it was full of seeds as a symbol of Seth's violent ejaculation.

While Isis may be a hard nut for Seth to crack, don't forget that among the extended family of the

gods, there is also the beautiful Anat. Anat was not originally an Egyptian goddess – she originated in Assyria where she was known as Inanna. From there, she moved to Phoenicia and Syria, where she was known by the name of Ashtoret, and in Egypt, she united with the Egyptian goddess Astarte, the daughter of the sun god, Re[8].

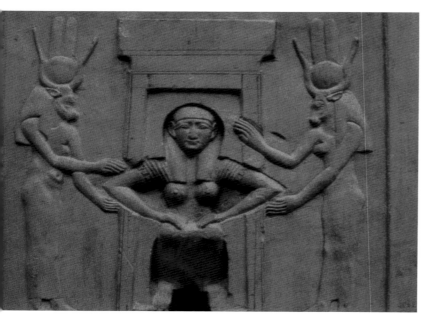

In Egypt, she assumed the role of the moon goddess, served as the goddess of war, and was known as a goddess of great beauty. Anat was bathing in the waters of the river, completely naked, of course, when Seth appeared in the form of a ram and copulated with her as deer do (from behind). At that moment, the sun god passed by, and the bellows and groans of the couple brought him to the riverbank – exactly at the moment when Seth the ram ejaculated with a huge trumpeting cry. Unfortunately, a few drops of Seth's semen sprayed forth, and instead of being absorbed into Anat's womb, they hit the sun god's forehead. Re returned to his palace, fell ill, and took to his bed. Naturally, Anat came along later to visit him, and he yelled at her: "How do you behave, you warrior goddess? You, the daughter of gods, present your backside to every man and to every animal like a whore! Did you come here only to liberate Seth from the pain in his loins? Is it not a disgrace for the one who was the sun god's wife to lie with Seth, who sows in her a rotten seed and opens her body with a hot skewer?" He continued scolding her, but his final conclusion was actually: If you need someone to copulate with – here I am!

At this point, the sun god was sick and tired of the endless quarrels among his offspring, and he banished Seth and Horus, just like Adam and Eve were expelled from the Garden of Eden. However, this did not put an end to Seth's schemes. Horus might not be as beautiful as Isis, but he was a young god. That was how Seth invited Horus to come and live with him in his palace. He solicited him with a tasty meal and a quiet conversation, at the end of which both of them went to bed – together – naked, according to the Egyptian custom. When they lay down to sleep, Seth said to Horus: "How beautiful your buttocks are. Let's arouse each other and have some fun." Horus, however – whose mother, Isis, warned him against lecherous acts like that – claimed that Seth was too heavy for him, "for I am a thin youth," and they made do with mutual caresses. During the night, "Seth brought on an erection with pleasant thoughts...[9]", placed his member between Horus' buttocks, and brought himself to orgasm. Horus, who was awakened by the act, remembered the warning of Isis, his mother[10], and managed to place his hand between his buttocks and catch Seth's semen in his hand. Here, Horus revealed himself as a typical son of the gods – he yelled to his mother, Isis: "Mother! Mother! Come see what Seth did to me!" and his mother hurried to him. He opened his hand and showed her Seth's semen and she, in a rage, pulled out a knife, chopped off his hand and threw it into the river. (Don't worry, she found another hand immediately and joined it to Horus' arm as a substitute.)

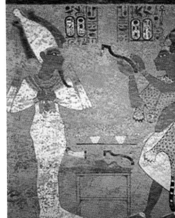

That was not the end of her work for the night, however. Isis brought a fragrant ointment with which she anointed her son Horus' member... "Up and down, round and round, she rubbed in the mixture, massaged the flesh of his member, until it was as erect as a spear in the hand of a warrior... She massaged the head [of his penis]... she massaged the flesh..." and when Isis felt that Horus was about to ejaculate, she took a jar and placed it next to the tip of Horus' member. All of his semen spurted into the jar, and Isis took the jar containing the semen with her.

In the morning, Isis walked to Seth's garden and asked the head gardener: "What does Seth eat when

he comes to his garden?" The gardener replied: "Here Seth does not eat anything except for fresh lettuce[11]." Isis then sprinkled Horus' semen over the lettuce leaves.

Seth did indeed come to the garden, ate some lettuce, as usual [after all, he had to revive his virility which had waned during a night of lechery], and became pregnant as a result of eating Horus' semen on

the lettuce leaves [but he did not know it yet][12]. When he finished, he invited Horus to go with him before the council of the gods. They came to the council, and, upon receiving permission to speak, Seth said: "I deserve the job [of ruler] that was Osiris', and Horus, who is standing next to me, doesn't, because I mounted[13] him."

The gods screamed in astonishment, but Horus laughed heartily and said: "Seth is lying. Let the semen attest to who mounted whom!"

Thoth was responsible for the semen test. First, he touched Horus' shoulder and said: "Out you come, Seth's semen!" Only the water in the little pool bubbled loudly. Afterwards, he placed his hand on Seth's shoulder and said: "Out you come, Horus' semen!" And the semen answered aloud: "Where should I come out of?" "Come out of his ear," replied Thoth. "I am violent semen! Shall I come out of an unimportant ear?" said the voice angrily. "Come out of the forehead[14]," answered Thoth.

Horus' semen came out of Seth's forehead in the form of a golden halo, and Thoth stretched out his hand, caught the halo, and placed it on Horus' head. "Horus is right, Seth is wrong," he ruled. In this way, despite Seth's tricks, Horus finally became his father's successor.

1 According to various sources, Hathor was the sun god's contemporary and was created together with him from nothingness (in other words, she was his sister). According to other sources, she was the god's right hand and was created after he masturbated for the first time. Although she had a respectable husband (Horus from Edfu), she had sexual relations with all the gods, to the point that she was called – as a title of honor – the womb of the world, or the sweet nakedness of the gods. She represents mature, independent, wild womanhood. The expression "Hathor's womb" appears in a medical papyrus, and it refers to a womb that is insatiable.

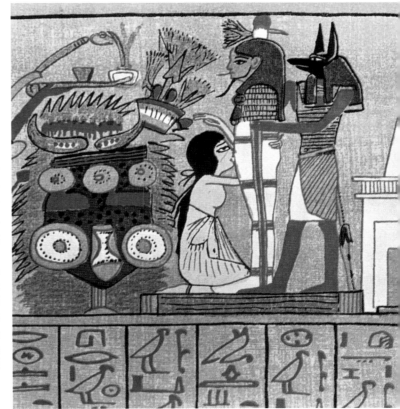

2 From the linguistic point of view, there is an Egyptian play on words here. There is a similarity between the expression "open nakedness" and the word "Dendara", the place in which Hathor's ritual was central.

3 A more appropriate expression would be, perhaps, "rocked". In Sudan (the location of Hathor's ritual), there is a position known as "the position of the sun", in which the man lies on his back and the woman sits on his penis and rocks back and forth. In contrast to other positions (in Sudan), whose aim is to lead to the man's climax as quickly as possible, this position is deliberately meant to prolong intercourse and frequently ends without ejaculation.

4 Apparently, bread from the table of the gods was thought to be a gift that was irresistible. In a Greek manuscript from the first century BC, there is a passage that tells of a wizard who obtained "bread from the table of the gods". He went on a voyage along the shores of the Mediterranean Sea that began in Tyre and ended in Alexandria, and enjoyed the favors of the most beautiful women for a crumb of bread. In this story, the bread of the gods ensured eternal youth for any woman who partook of it.

5 So that Seth had no rival for the girl's heart.

6 It is obvious that the fable is about Osiris, Horus and Seth.

7 In the Jewish Halacha, there is a rule of "the majority rules".

The problem that arose was of a woman who was raped beside the walls of the city, became pregnant, and gave birth to a son. Was the son Jewish? The rabbis ruled that the population of the city had to be inspected. If the majority was Jewish, the son was a Jew, and if the majority was not Jewish, the son was not a Jew. The dispute concludes as follows: "We shall do according to the custom

of the Egyptians, for even the whores [there] count the men, each man to his people [his religion], while they stand in front of the judge to say whose son [was born] to them."

8 A clay tablet that was found in ancient Babylon tells of daughters of nobles "...who go down to the big river, to the country [of Egypt]...where there is the bull, as well as the deer, as well as the horse, as well as the donkey...like husbands to them...They do not [do] as the goddess does... and return to the city that is surrounded by walls [Babylon] and serve in the temple [women were supposed to serve as ritual prostitutes in the temple at least once a year] as the simplest of women..."

9 Apparently the source wished to stress that in spite of the fact that Horus was young and handsome, Seth still thought about women [Isis] in order to get an erection.

10 Another source relates that Isis warned her son that Seth's semen must not see the light of day, since he would then be like poison to Horus. The following is said about semen in an extract from an Egyptian poem: "...In a woman's womb it arouses pleasure, in the light of day it is a deadly poison..."

11 Lettuce was the main aphrodisiac food in ancient Egypt. The superiority of lettuce was stressed in the various Egyptian medical texts, and a dream about lettuce was a dream in which passion and lust were involved. Egyptian delegations would bring offerings of lettuce to foreign kings and rulers. A papyrus from the eighth century BC mentions the case of a farmer who raped a young girl on his way home from the field. In his defense he claimed: "...The whole day I worked in a lettuce field." The penalty? The judge ordered him to take his wife with him to the field while he was growing lettuce.

12 The meaning is that the semen "took" as if Seth were a woman.

13 The exact Egyptian expression is "I performed an act of domination on him". In ancient Egypt, as in other ancient cultures, there were degrees of status in sexual relations between men – the one who penetrated was always the ruler, while his partner, who was sometimes called the "boy" or even the "girl", was subordinate to him.

14 The forehead, from where the semen came out, and where Seth's semen hit (the sun god), is the place where the third eye is located. The Egyptians believed in its existence and its importance.

"The Dark Friend of Bradhara"

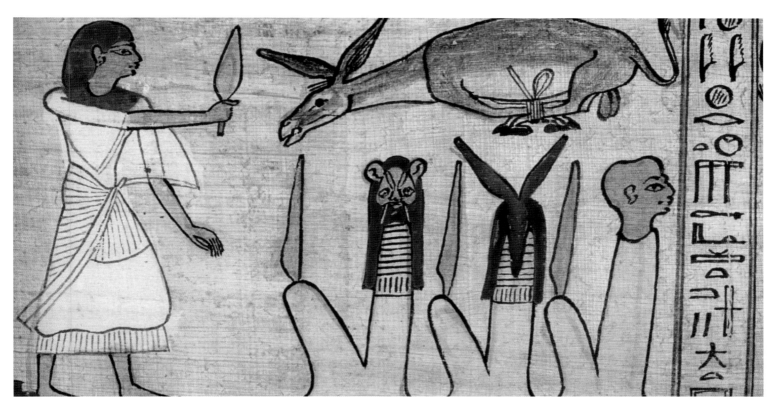

The following excerpt is taken from an adventure story in the style of the Galgamesh Tales, and is entitled "The Dark Friend of Bradhara". The sources of the story are found in the Sanskrit language from an unknown period. In 1873, part of the text was published in a private edition that was based on a manuscript from the third century AD. This text has been translated into English but has not yet been published.

Bradhara, a prince, the son of a king, sets off on a voyage in a sailing ship, and is abducted by pirates. (This sentence summarizes about 40 chapters in the book.) He is thrown into a dungeon because his father died during his absence and there is no one to pay a ransom for him. In the dungeon, he meets the "friend" (his name is not mentioned throughout the entire lengthy work) – a gigantic, hirsute man with long arms and bandy legs, who does not speak any human language and is bound to a ring in the wall by an iron chain. The pirates are arguing about whether he is a human being or some kind of demon. Finally, one of them suggests sending the female Egyptian prisoner to him, "For if he is a man, how can he control his lust in her presence?"

From the corner of the dungeon, Bradhara gazes at the Egyptian prisoner, "who is completely beautiful, tall as the palm tree, her black hair like a wave on her shoulders, and when she moves, men's hearts move with her steps…." When the captors tear her robe from her body, Bradhara looks away modestly, but manages to see that "her breasts are round like fruit on the tree, and her belly is like the mound of salt that collects on the rocks of the sea…." The captors place a sword on the Egyptian woman's neck and command her: "Seduce the man-beast, because we know that there is no man who will not succumb to the temptations of Egyptian women." They promise her that she will win her freedom if she seduces her victim… Alternatively, she will be beheaded if she is "not an Egyptian woman" – in other words, if she fails to accomplish her mission.

The act of seduction is described in paragraph after paragraph. The description resembles that of the dance of a stripper. Everything takes place at a safe distance from the man-beast tied to the wall. However, it is Bradhara, who "has never known the ways of the Egyptian women", and who "has not slept with a woman for many months," who becomes aroused, reaching the point that "if there had been a toothless widow [next to him], who was as old as his great-great-grandfather, he would have thrown her on the stone floor at that moment and assuaged his raging soul."

However, at this stage, the man-beast becomes aroused, tearing out his chain in his lust… and pounces on his captors, the pirates. At the end of a bloody struggle, he releases Bradhara, and, along with the Egyptian captive, they escape from the dungeon.

This is the beginning of an adventure-packed journey, the ultimate aim being to restore the prince to his father's throne. Bradhara's hairy friend fights his enemies, the Egyptian woman sells her body in order to earn money for the prince's needs (since, of course, he cannot go from one place to the next without the suitable princely conditions!), and Bradhara makes do with philosophical deliberations such as: "Indeed she is a woman, and she is more beautiful than any other woman I have ever seen, but she is an Egyptian, and I have heard a rumor that Egyptians are like whores. Why should I complain when her harlotry served a noble purpose [that is, fulfilling his needs]?" During the entire journey, the prince is tormented by his passion for the Egyptian woman, and only after he – with the help of his friend – has banished his brother, who has usurped the royal throne, does he decide that "she is more worthy of me than all the king's wives" and makes his way to the room that has been allotted to her… There he discovers his hirsute friend in the Egyptian woman's bed, celebrating the end of the journey. In a blind rage, the prince cuts the woman's head off, and after a battle with his friend (who, ten pages previously had annihilated all the guards of the treacherous brother with his bare hands), he kills him, too.

In his sorrow at his friend's death, the prince buries both of them in the same grave that is known by a name whose meaning only is given: "Even the hero of heroes cannot resist the whore of Egypt". He spends the rest of his life writing a book called "Even a monk will be seduced by the Jewel of the Rising Sun" ("the Jewel of the Rising Sun" sounds like "the Beautiful Egyptian Woman" in the Sanskrit language), which, regrettably, has not reached us.

And Joseph found grace in his sight, and he served him: and he made him overseer over his house, and all that he had he put into his hand. And it came to pass from the time that he had made him overseer in his house, and over all that he had, that the LORD blessed the Egyptian's house for Joseph's sake; and the blessing of the LORD was upon all that he had in the house, and in the field. And he left all that he had in Joseph's hand; and he knew not ought he had, save the bread which he did eat. And Joseph was a goodly person, and well favoured. And it came to pass after these things, that his master's wife cast her eyes upon Joseph; and she said, Lie with me. But he refused, and said unto his master's wife, Behold, my master wotteth not what is with me in the house, and he hath committed all that he hath to my hand; There is none greater in this house than I; neither hath he kept back any thing from me but thee, because thou art his wife: how then can I do this great wickedness, and sin against God? And it came to pass, as she spake to Joseph day by day, that he hearkened not unto her, to lie by her, or to be with her. And it came to pass about this time, that

Joseph went into the house to do his business; and there was none of the men of the house there within. And she caught him by his garment, saying, Lie with me: and he left his garment in her hand, and fled, and got him out. And it came to pass, when she saw that he had left his garment in her hand, and was fled forth, That she called unto the men of her house, and spake unto them, saying, See, he hath brought in an Hebrew unto us to mock us; he came in unto me to lie with me, and I cried with a loud voice: And it came to pass, when he heard that I lifted up my voice and cried, that he left his garment with me, and fled, and got him out. And she laid up his garment by her, until his lord came home. And she spake unto him according to these words, saying, The Hebrew servant, which thou hast brought unto us, came in unto me to mock me: And it came to pass, as I lifted up my voice and cried, that he left his garment with me, and fled out. And it came to pass, when his master heard the words of his wife, which she spake unto him, saying, After this manner did thy servant to me; that his wrath was kindled. And Joseph's master took him, and put him into the prison, a place where the king's prisoners were bound: and he was there in the prison.

(Genesis 39, 5-20)

Ritual Necrophilia

Ancient Egypt was well-known for its dead and for its attitude toward the dead, and the members of the various peoples who visited Egypt wrote down their great impressions of the attitude toward the dead and of the Egyptians' embalming practices, from Herodotus to 20th-century travelers who watched sex shows that "reconstructed" the wonders of ancient Egyptian erotica for tourists. Among other things, various travelers described practices of intercourse with corpses – necrophilia – both with dead women and dead men. A third-century Greek traveler writes about this practice:

"…And the custom of the ancient Egyptians is to come to [copulate with] beautiful women after their death, and that is what the priests and the people who lay out the dead [the embalmers] are in the habit of doing. And if among them [the women] there are any who had not known a man, they bring the head of the chamber… and afterwards she can be used by everyone. For this reason, they [the Jews] in Egypt are in the habit of concealing the woman's body for days, until decay sets in, and then bring it for burial… while in their cities [in the cities of the Jews?] they bury their dead on the day of his demise."

This necrophilia, which was practiced by the Egyptians, was to a large extent ritual and religious. In the Egyptian story of the Creation, a considerable chapter was devoted to the birth of Horus, and the most widespread and popular is the one that describes necrophilia among the gods. The story presented below is based on written sources that were found in the Louvre museum in Paris, and date back to 1500 BC, sources that are validated by many paintings and reliefs.

"I am Isis the beneficent, Isis who protected her brother Osiris, who looked for him unceasingly, who did not give herself rest… until she found her brother1… And in the shape of [a bird] hovered above him, and with her wings blew breath [into the dead]… I am Isis, who assumed the role of the man2 (even though I am a woman) in order to keep the name [Osiris] alive. I am Isis who breathed the breath of life into the dead member3 [penis] of my dead brother in order to absorb his seed and give birth to his heir… I am Isis who lay with her dead brother and became pregnant by him."

Therefore, when the Egyptians engaged in acts of necrophilia, they did not view it as a weird perversion, but rather as an imitation of an act of the gods. In the Books of the Dead (that were written for women and for men separately), we find comments such as: "Blessed is she [the woman] who enters [the gates of death] with semen in her body…" Or, in the male version: "… he who brings his semen [with him], beloved he will be…"

1 The term "brother" here describes the family tie of husband/brother, as does the term "beloved."
2 That is, I took the initiative from the "penisless" Osiris (see footnote number 79).
3 According to the Egyptian story of the Creation, Isis found all of Osiris' body parts (and joined them up into a whole body) except for his penis. In order to preserve consistency, various commentators read the passage as follows: "I am Isis who grew a member like a man…" and in another case: "…and by means of a reed that looked like [a penis] I lay with the dead." To our mind, there is no need of this.

There was a man, a stonecutter, by the name of Ti, the son of a farmer and a mother called Kattahut[1], and he was so good at cutting stone that the king's agent[2]… asked him to go to the cities in the north and carve a statue of the king so that the foreigners could see the power of the king of Egypt and would bow their heads to him.

Ti took his tools and set off, and at the command of the king's agent, boarded a boat and disembarked at the river [Nile], where he joined a caravan of merchants with whom he traveled through the desert[3] until he reached the city of Tyre[4], and there he made his dwelling place. And the king's agent brought him to the governor of the city, and the latter gave him [a place to work]. And very soon he had made a name for himself throughout the city [women], because he was a stonecutter in the Egyptian style[5], and his member hung down between his legs in full view. And the women [of Tyre] would come to see him, because he was bigger than anyone they had ever seen. And one woman, the wife of a baker, became emboldened and came to him at the hour when the fishing boats turn away from Horus[6], and standing in front of him, lifted up her garment. And upon seeing her black pubic hair, because pubic hair was not removed there [in Tyre][7], he became aroused and smiled at her. And upon seeing that [he had understood her intention], she lay down on her back. Ti was a farmer's son and did not understand her intention, because when he was [in Egypt] the women presented their bottoms.

Ti quickly grasped the chisel with which he was sculpting the outlines of the king[8] and diving onto the ground, he rapidly sketched what [he wanted], since he did not speak her language. And the baker's wife understood what he wanted and presented her bottom to him, pulling up her garment and kneeling down[9], and Ti came into her and shouted that her Kat [hole] was as hot as an oven. And this is what is said in Tyre: Happy is the woman who knows an Egyptian [man].

1 The meaning of the name hints that the mother was a frivolous woman – "a hole used by everyone."
2 This probably refers to Rameses, and it pinpoints the timeframe of the story to the first millennium BC.
3 "Desert" in the sense of "a land without a river."
4 The name is distorted, but it seems that the choice of the name "Tyre" is appropriate. Tyre was a Phoenician port city in the south-west of Lebanon, and it had extensive ties with the Egyptians.
5 The Egyptian garment looked like a dress, open in front, so that the genitals were not covered.
6 Evening time, when the boats returned eastward from fishing with their backs to the sun setting in the west. This was the time in which the women waited for their husbands to return home, and the fact that it is mentioned serves to emphasize two things: the baker's wife was alone with the stonecutter, and she was a "bad" woman because she was not waiting for her husband at home.
7 Not all of the Egyptian women removed their pubic hair either, but the custom of removing the hair was prevalent in Egypt.
8 The stonecutter would sketch the outlines of the figure with a chisel and would then cut the stone according to the lines.
9 The "official" Egyptian position was this one, which was called "the bull position" in Lebanon. Low-class Egyptians did not usually copulate in daylight (in the sight of Horus), but when they did, they tried to perform the act in the accepted "official" position in which neither of the partners had to look upward.

I saw beside the water [canal]

What I dreamed about at night.

Erect she was like the date palm

Her hair as black as a [raven's] wing.

She turned her gaze to me,

Her eyes like deep [water] holes[1],

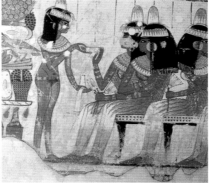

Her breasts round[2] like heaps of wheat,

Adorned[3] with a grape dripping juice.

I walked at her side until evening[4],

The cool winds blew,

She [my girl] smiled at me and turned her back [to me]

Her hand on the high [milestone?],

And as I held her hips,

She became my woman[5].

1 An expression that indicates very dark or black eyes.
2 The wheat was piled up in round heaps or silos.
3 A description of the nipples.
4 After the sun goes down. The Egyptians did not encourage adultery or fornication "under the eye of Horus" [the sun god].
5 A French lecturer whose lessons I attended would say – either in jest or seriously – that "in ancient cultures, adultery was always committed from behind… in this way the man could always justify his actions by claiming that it was a case of mistaken identity!" [J.T.]

In a medical papyrus from the third dynasty, 37 different potions used for various diseases and problems are mentioned. The list of the ingredients required for the potions mentions a man's "semen" 14 times, a woman's "juice" 11 times (it was collected by stimulating the vagina and collecting the moisture), various animals' "semen" or uterine "fluids" 11 times, armpit sweat 10 times, pubic hairs seven times, menstrual blood six times, "dried and finely ground nipples" three times, and… a testicle that had been preserved in a water skin once.

In a papyrus called the Sallier Papyrus (BM 10184), we can find admonitions or warnings such as:

On [day], bad luck prevails. Do not have intercourse with a woman under the watchful eye of Horus [the sun]...

On [day], bad luck prevails. Do not take a woman to your bosom on this day... and the one who is born [or is conceived] on this day will die during intercourse.

Yet she multiplied her whoredoms, in calling to remembrance the days of her youth, wherein she had played the harlot in the land of Egypt.

Ezeqiel 23.19

Dream Books and Erotica

The dream books that were widespread in Egypt – unfortunately, very little of them remains – reveal a broad spectrum of varied erotic activity, and sometimes even activity that is considered deviant. The Egyptian dream books were preserved mainly in the writings of peoples who knew the Egyptians, such as the Jews[1], the Greeks or the Romans, but here we discuss details that we managed to find in the original writings that were preserved (particularly papyrus BM 10184 from the 12th century BC and the Carlsberg Papyrus from the second century AD).

If a man dreams that his phallus is big: His wealth and property will increase beyond measure[2]. Good.

If a man dreams that he is copulating with his mother: His friends will stay with him for a long time. Good.

If a man dreams that he is copulating with his sister: It is a sign that he will inherit a handsome inheritance. Good.

If a man dreams that he is copulating with a woman[3]: Sorrow and grief. Bad.

If a man dreams that he is copulating with a female marsupial[4]: A verdict will be given against him. Bad.

If a man dreams that he sees an erect phallus[5]: He will be robbed. Bad.

If a man dreams that he is copulating with a bird of prey[6]: He will be robbed. Bad.

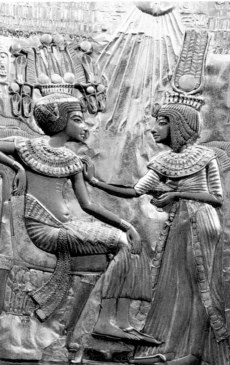

If a man sees himself shaving his genitals[7] in a dream: Sorrow and grief. Bad.

If a man sees a woman's pubis in a dream: A great disaster. Bad.

If a man dreams that he is copulating with a pig[8]: He will lose his possessions. Bad.

If a man dreams that he is copulating with his legal wife in the sunlight: The god [Horus] will show his torments. Bad.

If a man dreams that he is copulating with a crocodile[9]: Wealth will come to him. Good.

If a man dreams that he is copulating with a maidservant of his household: A disease will befall his children. Bad.

If a man dreams that he is playing at copulating[10] with a young girl: The god ... will be angry at him. Bad.

If a man dreams that he is playing at copulating with his daughter: He will live long. Good.

The Egyptian dream books had specific uses: there was a book for men, a book for women, a book for priests, a book for military warriors and so on. We have several detailed sources, but most of them postdate the first century AD. We have not managed to find a reliable source that predates the third century BC.

If a woman dreams that she is married to her husband, she will be destroyed.

If a woman dreams that she embraces her husband, she will have a great deal of sorrow.

...[11] If a woman dreams that a mouse copulates with her, her husband will give her...

If a woman dreams that a farmer[12] copulates with her, the farmer will give her [a ransom?]...

If a woman dreams that a horse copulates with her, she will raise her hand to her husband.

If a woman dreams that a donkey copulates with her, she will receive a harsh punishment.

If a woman dreams that a he-goat copulates with her, she will die quickly.

If a woman dreams that a ram copulates with her, the ruler will look favorably upon her.

If a woman dreams that a wolf copulates with her, she will see something that she considers beautiful.

If a woman dreams that a snake copulates with her, she will have a cruel husband and will become ill.

If a woman dreams that a crocodile copulates with her, she will die soon.

If a woman dreams that a baboon copulates with her, she will look favorably upon people.

If a woman dreams that an ibis copulates with her, her home will be spacious.

If a woman dreams that a falcon copulates with her, her fate will be bitter.

If a woman dreams that a bird copulates with her, her rival will prevail.

...[13] If a woman dreams that a married woman copulates with her, her fate will be bitter and one of her sons...

If a woman dreams that a wild woman[14] copulates with her, the wild woman will take her husband and she [the dreamer] will be found dead.

If a woman dreams that a female[15] copulates with her, she will utter a lie.

If a woman dreams that a Syrian[16] copulates with her, she will weep copiously [because she lets her house slaves copulate with her].

If a woman dreams that a stranger[17] copulates with her, she will weep... and when she displays generosity to every stranger that comes to her house, her husband will take another wife over her.

If a woman dreams that an unknown person[18] copulates with her, she will become invisible.

If a woman dreams that one of her sons copulates with her, one of her sons will disappear.

1 In prior dream dictionaries of the Jews, 11 out of 15 of the examples presented here appear word for word.

2 In another version: If a man dreams that his penis grows until its length is greater than the man's height.

3 A woman who is not related to him.

4 In many versions: A female jerboa. The female marsupial has two "vaginas" or vaginal openings, and the males have a split, fork-like penis with two heads. In Australia, the custom of "kangaroo circumcision" is known. This is a cut made along the length of the penis in order to split it into two heads, so that it resembles that of the kangaroo (perhaps in the hope of gaining the copulatory power of the kangaroo, which can sustain double-penis intercourse for hours). In Egypt, three items representing a double penis and several dozen clay figurines representing female genitals with two apertures have been found.

5 Someone else's, not his own. It means "If a man sees an erect phallus in the place where his own phallus was supposed to be," that is, if a man sees that he is being betrayed.

6 In other places, a kite is mentioned specifically.

7 The stress is on "himself." Shaving the genitals was widespread and was done by a partner or a professional "shaver." It means, "If a man does not have anyone to shave…"

8 The pig had many beliefs attached to it in Egypt – from a strict prohibition not to eat pig meat (except for one day a year) to a belief that the gods dress up as pigs and come to copulate with women.

9 A well-known and popular Egyptian custom. At the end of the first century BC, a group of Egyptians (men and women) appeared in Rome. They copulated with crocodiles in live pornographic shows. A well-known statue depicts Cleopatra copulating with a crocodile. In the 19th century, the French author, Gustave Flaubert, described an amusement show that he and his companions saw in Cairo, in which a man and a woman copulated on the same stage with a donkey, a crocodile and with each other for dessert. In 2001, a seal of a merchant from Siva (a city on the Egyptian-Libyan border that was known for its lasciviousness) that represented his occupation as "a bringer of the river crocodiles for the use of men and women" was found.

10 A sex "game" in which the man rubs the tip of his penis against a young girl's vagina was widespread, popular and desirable in the Egyptian culture. However, when this "game" led to the penis penetrating into the vagina beyond the circumcision line, it was considered to be unacceptable copulation.

11 This list consists of a dozen animals, from a little mouse to a horse, from Egyptian domestic animals such as a horse and a donkey to the birds of the sky, crocodiles of the river and snakes. In all, 37 identifiable creatures with which women would copulate are mentioned in the Egyptian texts.

12 Meaning common people. The dream books were meant for women from noble or wealthy families who knew how to read and write.

13 The three examples of females (a married woman, a wild woman and a female) are the most reliable testimonies to the existence of an extensive lesbian culture in Egypt.

14 A wild woman, meaning a potential ally. The Egyptians divided the world around them into Libya (North Africa to the west of Egypt), Nubia or Kush (the territory to the south of Egypt – Sudan or Africa) and to the "white land", which was briefly related to as Syria, Israel, Cyprus and so on. "Wild woman" was the name given to women who came from the far north and usually had white skin, which was considered to be a sign of beauty.

15 A woman about whom nothing is known.

16 This line shows that the writing of this dream book began in the period in which Egypt ruled Syria and brought slaves from that country.

17 Meaning that "he is not Egyptian." In another version, the term "Nubian" (Sudanese) appears, and in yet another version, the term "a stranger with ash-colored skin" appears.

18 Whose name is unknown, but he is Egyptian.

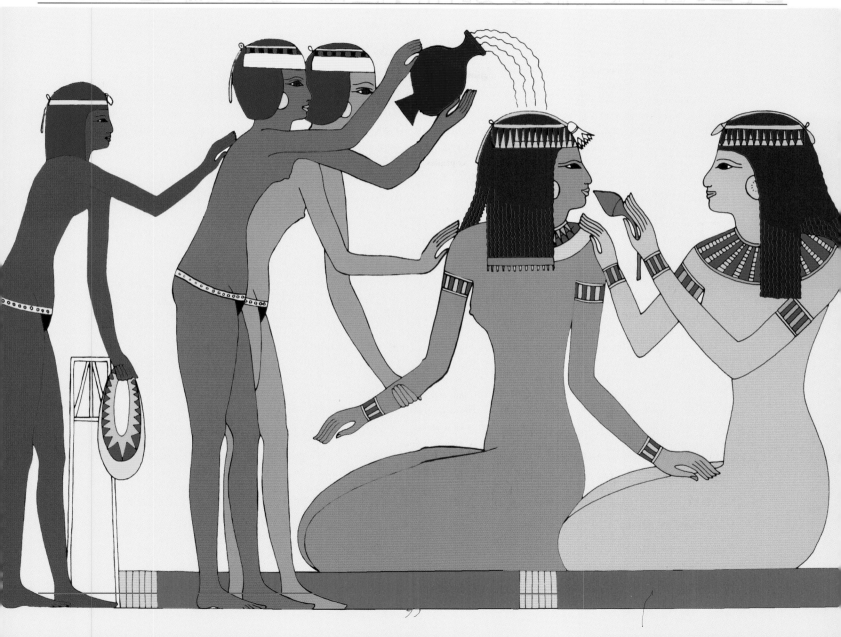

The Marriage Age

The marriage age in ancient Egypt, according to various testimonies, was amazingly low… for women (or actually for girls). A man got married at an age when he had some kind of status, that is, when he could support himself. According to ancient Judaism, for instance, the age for a girl was 12, the age at which she was ripe for marriage (age when menstruation occurs and the pubic region becomes covered with hair). At this age, the young Egyptian girl was considered "old for marriage": *"If a man marries a six-year-old he will be filled with pleasure from her sweet flesh, from the pleasantness of her ways. If he takes a girl of a dozen years, he will ask for a double dowry because her youth has ended."*

Even though there are various sources (inscriptions, papyri and wall paintings) that attest to the fact that the actual marriage age for women in ancient Egypt was higher than the age of childhood, there is also a great deal of evidence to the fact that five- and six-year-olds were forced to perform the duties of the married woman. In various papyri, we see images of completely nude girls, when the Egyptian custom held that a girl who had reached puberty, that is, "was ripe" for marriage, had to wear a garment. All of the clothed girls have developed breasts and pubic hair that is visible through their garments – that is, they are 12 or older. On the other hand, we find a "medical" story about a man who married three girls one after the other – they were "so young that they were sealed [that is, their pubis was 'closed'] and when he came to them like a man comes to his wife, they bled to death… until the account of his deeds reached the ears of the royal physician, who approached Pharaoh, and on the latter's command, the man was forbidden to marry a woman who had not passed blood [that is, who had not had her first period]. And the man came to Pharaoh and said: Am I a leper? And why can I not be like all the men of Egypt?"

Women and Men had Equal Rights

In the long history of the Egyptian pharaonic dynasties, we can find occasional women's names – female rulers, whose names were written down in the pages of history. Meryetnit, from the first dynasty (some 5,000 years ago) is thought to be the "big mother who united north and south" (Upper and Lower Egypt). Hatshepsut, the widow-queen (1505-1483 BC) was given the name "the great merchant" and it is actually she who caused the Egyptian merchants and their cargoes to reach China on one hand and the north of the English island on the other. Her influence was so great that the artists of her time placed the symbolic beard on her chin. The next on the list were Berenike, Tiy, Nefretiti, Arsinoe, and of course Cleopatra (the seventh) – all of them women who made their mark in a world ruled by men.

According to Egyptian law, women and men had equal rights (in theory, at least). The rights that were granted to women according to Egyptian law were "scandalous" in the opinion of the ancient Greek and Roman historians, who had the examples of their own cultures in front of their eyes, cultures in which women were virtually slaves.

In fact, in Egypt too, the status of the woman was determined mainly according to the value of the property she controlled, property that she acquired in most cases through inheritance. Only a few women were able to earn sufficient money to become influential – most of the women were housewives or slaves, and women who earned a lot of money were prostitutes who varied their physical occupation with singing, playing or dancing.

Beating women was widespread in Egypt during all eras. We find testimonies to this way of life both in the stories and in the songs that remain from ancient Egypt, both in wall paintings and in archeological evidence (in skeletons of Egyptian women, we find many bone fractures that are characteristic of beatings). In an Egyptian text from 4,000 years ago, we find the following lines:

"My husband beat me with a whip,
He broke my arm as if it were a reed.
My eldest son kicked me,
I couldn't get out of my bed in the morning."

Despite the apparent equality of men and women, for thousands of years the ancient Egyptian women were forced to pay for the crimes of their husbands. When a man was put on trial and sentenced to a penalty, the punishment was also administered to his wife and her children. A common practice was to sell women and their children into slavery in order to cover the husband's debts.

Cleopatra

It is important to mention that in Egypt, a woman could divorce her husband for any reason. While in other cultures, such as the Sumerian, the Babylonian or the Jewish cultures, the main reasons for divorce were the wife's sterility or [her] adultery, in Egyptian law and customs the reasons were extremely varied, from a situation in which the husband's "pocket is meager, and he does not bring meat, wheat and beer back to the pantry," to a situation in which "he goes out every night, spreads his seed around in houses of pleasure… and comes back to my bed dry like a dried reed…" (that is, he cannot satisfy his wife sexually).

During certain periods of the Egyptian dynasties, polygamy was widespread, while during others, even though the culture was monogamous, there were various arrangements that enabled men to live with several women.

In Egypt, as in Babylon and other cultures, a woman was essentially property – first the property of her father, and then the property of her husband. Her main function was to be the mother of her husband's children and a housewife, and she accumulated money only as a result of inheritance.

Cleopatra

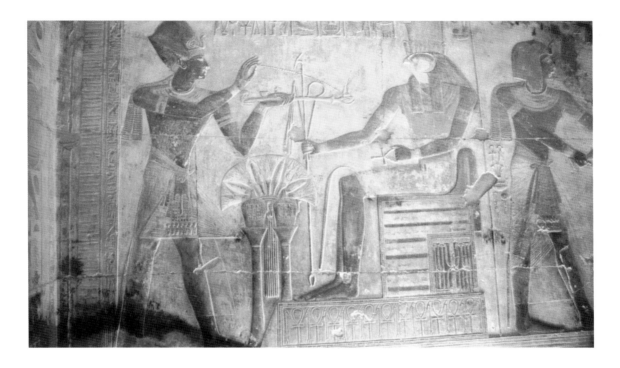

"Take a wife while you are still young
She will pleasure you in your bed,
She will see to the running of your household,
She will give birth to your son.
Happy is the man whose wife gives birth to his sons while he is still in his youth
And very many are his sons."

Two extracts from a "medical" book – actually the memoirs of a priest-physician – etched onto the walls of his tomb:

"And afterwards came before him a man in his prime, a master craftsman in stonecutting, who was one of Pharaoh's loyal men in [the construction of] the great tomb, and his illness was a men's illness, because he did not have the strength to perform the custom [of intercourse] with his wife... And I had the mixture that I had made up for ... at hand, and I gave it to him, since the seeds of the lettuce[1] and the seeds of the lotus[2], together with the tail of the crocodile and the eye of the water fowl[3] ... are good for copulation. And I gave him a piece of advice: Before going to bed, order a good-looking slave and maidservant [to copulate] in front of you, and only then turn to [your wife]...

"And there was a woman who had given birth three times, and each time [her husband had intercourse with her] she would bleed copiously[4] ... And I prepared the green ointment[5] for her so that she could anoint her wounds, and I told her: Do what the goddess did – she got on top of her husband and took the role of the man... and it will be easier for you.[6]"

1 Lettuce is considered to be an aphrodisiac.

2 Lotus is the most erotic plant in the Egyptian culture.

3 Probably an ibis.

4 The beginning of the sentence makes it quite clear that the blood does not come from a broken hymen nor is it menstrual blood.

5 There is a lengthy description of the green ointment in another place. It is meant for wounds inside the body apertures (vagina, mouth, ear, and so on) and consists of 17 ingredients.

6 Isis. This means that the woman should be on top of her husband in order to determine the depth of penile penetration into her vagina.

Nefretiti

"The Prince of the Nile"

"There was a man in the land [Egypt], a very famous and courageous general, who forced the boldest of men into submission, who conquered fortified cities, who turned [the mountains] into plains. And when he returned to the sacred river[1], he built his house in the place [Pharaoh] allocated to him[2].

"One night, while lying on his bed, his desire [for a woman] rose and as he was a man [who was not married], he went to the maidservants' room[3] and upon entering the room saw a young maidservant he did not know lying on a bed. She was a Nubian[4], her skin was as black as the black of night, shining from the oil she spread over her body. Her eyes were as deep as wells, and their color was like the bud of the lotus flower. Her breasts rose rounded like the sand hills in the burning desert[5]. Her slender legs embraced the pillow[6] like a woman embraces her lover. And when he saw her, his desire overwhelmed him,

and when he pulled [the cover] from her body, he lifted her[7] [onto her knees] and performed an act on her, while the other maidservants remained silent on their beds.

"And when [the master] left the room, the maid returned to her bed and covered her head. She was a Nubian, the tenth daughter of a prince, who had been sent [to Egypt] to find a husband. She was making her way in the [royal?] caravan, when [bandits] attacked it, killed her guards, seized her possessions and sold [her] as a slave. And since she was the daughter of a prince from a Nubian tribe, there were many who courted her, and she consented to many, but no one had ever taken her like an animal[8].

"And since she was the daughter of a [Nubian] prince, she waited until morning light, and while [the other maidservants] were still fast asleep, she got up from her bed and left the room. Like a shadow she passed [the rooms], and when she passed by [the sculptor?], she took a small knife in her hand.

"The master's room was across [the passage], open to the big river. As silent as the morning breeze, she passed the slumbering guards and entered the room. Not a grain [of sand] moved beneath her bare feet. And thus she came to the master, and leaning over him, she cut off [his member] with a stroke of the knife, and while he was screaming in pain, she hurried out to the sacred river.

"Like a statue she stood there, on the bank of the river, and uttering [a prayer] she dropped the [member] that had defiled her honor into the water, to the hungry crocodile. And raising her arm so that she could plunge the knife [into her belly], the arrow shot by [one of the guards] hit her and she fell into the water…"

Hatshepsut

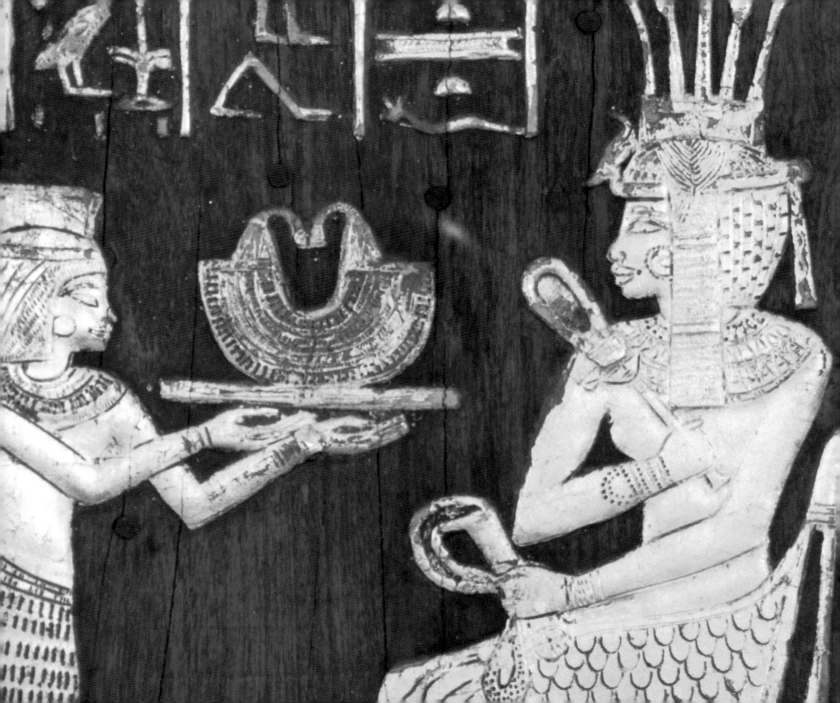

"And on that same morning, Pharaoh's chariot passed [that place]. And when he saw [the commotion], he went to the general's house, and when he saw what had happened, he feared for his life, and he sent for his priests [the physicians], those who are responsible for the dead and for the living, and ordered them to restore [the general's] strength to him.

"For ten days and ten nights, they were busy beside his bed, taking care of him with [ointments] and spells[9]. And for all those days, [the slaves] searched in the waters of the river. And when they saw that they only brought up sand and stones, they dried out the river[10], but all they found was a black stone statue of a woman as beautiful as Isis[11]. And that is the statue that [Pharaoh] placed on the border stone facing [southward][12].

And on the eleventh day one of the [house] guards saw the crocodile rising up out of the

water, and immediately shot an arrow into it. And when they brought the [crocodile's carcass] into the house, the priests found what they had been looking for in its belly… and they threw the crocodile back into the river, and there it recovered in the blink of an eye[13].

And [Pharaoh's] priests hurried to anoint the member[14]… and at the end of sixty days and sixty nights, they took off [the bandages]. And later on the general married a woman and sired three sons[15]. And from then[16] [the incident] until his death, the general would [copulate with] women in the way of the crocodile[17], so that he was called "the prince of the Nile".

Nefretiti

1 The Nile

2 Military figures would be granted estates on the borders of Egypt upon completion of their service. Consequently, we can assume that the general (whose name does not appear) had a house on the Egyptian/Sudanese border of today.

3 "Maidservants" were women with whom sexual relations were permitted, and their children were considered to be the master's offspring of an "inferior" rank.

4 The term "Nubia" relates to "everything south of Egypt", in other words, Africa.

5 A common simile for round breasts.

6 Many paintings feature women holding a long pillow. This pillow was used for sleeping (it was generally placed beneath the sleeper's legs), as a support during sex and for masturbation.

7 Even though the inscription is incomplete, we can assume that it describes a position that resembles the "grinding position" when the woman is on her knees and the man is behind her.

8 This does not refer to a position, but rather to intercourse without consent, or to rape. An Egyptian dream book from the same period states: "The woman who dreams that she is mated like an animal… just as she did not [want] to be mated, so she does not [want] bad luck."

9 Spells, like amulets, were part of the healing process.

10 The ancient Egyptians knew how to dry up parts of the Nile River by building dams and diverting the river.

11 There is a hint of irony here – Isis found Osiris' body parts, except for his penis, and the maidservant "removed" the penis without harming the other body parts. Therefore, perhaps it would be appropriate to write: "A woman more beautiful than Isis."

12 The Pharaohs set up border stones and various dolmens on Egypt's borders.

13 The passage is incomplete. The Egyptians considered the crocodile to be a sacred creature, and were not in the habit of killing it (especially not when it was "looking after" the penis). Thus, the passage opens with an arrow being shot, but ends with the return of the crocodile to the waters of the Nile.

14 A long passage that mentions several dozen ointments and spells used by the priests. Most of the passage is incomprehensible.

15 An ending that attests to the success of the treatment.

16 This part was apparently added later.

17 Crocodiles copulate face to face.

Egyptian Love Poetry, 2000 - 1100 BC

Your love has penetrated all within me
Like honey plunged into water,
Like an odor which penetrates spices,
As when one mixes juice in...
Nevertheless you run to seek your sister,
Like the steed upon the battlefield,
As the warrior rolls along on the spokes of his
wheels.
For heaven makes your love
Like the advance of flames in straw,
And its longing like the downward swoop of a
hawk.

Disturbed is the condition of my pool.
The mouth of my sister is a rosebud.
Her breast is a perfume.
Her arm is a............bough
Which offers a delusive seat.
Her forehead is a snare of meryu-wood.
I am a wild goose, a hunted one,

My gaze is at your hair,
At a bait under the trap
That is to catch me.
Is my heart not softened by your love-longing for me?
My dogfoot-(fruit) which excites your passions
Not will I allow it

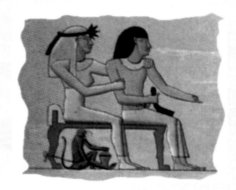

To depart from me.
Although cudgeled even to the "Guard of the overflow,"
To Syria, with shebod-rods and clubs,
To Kush, with palm-rods,
To the highlands, with switches
To the lowlands, with twigs,

Never will I listen to their counsel
To abandon longing.

The voice of the wild goose cries,
Where she has seized their bait,
But your love holds me back,
I am unable to liberate her.
I must, then, take home my net!
What shall I say to my mother,
To whom formerly I came each day
Loaded down with fowls?
I shall not set the snares today
For your love has caught me.

The wild goose flies up and soars,
She sinks down upon the net.
The birds cry in flocks,
But I hasten homeward,
Since I care for your love alone.
My heart yearns for your breast,
I cannot sunder myself from your attractions.

Thou beautiful one! My heart's desire is
To procure for you your food as your husband,
My arm resting upon your arm.
You have changed me by your love.
Thus say I in my heart,
In my soul, at my prayers:
"I lack my commander tonight,
I am as one dwelling in a tomb."
Be you but in health and strength,
Then the nearness of your countenance
Sheds delight, by reason of your well-being,
Over a heart, which seeks you with longing.

The voice of the dove calls,
It says: "The earth is bright."
What have I to do outside?
Stop, thou birdling! You chide me!
I have found my brother in his bed,
My heart is glad beyond all measure.
We each say:
"I will not tear myself away."
My hand is in his hand.

I wander together with him
To every beautiful place.
He makes me the first of maidens,
Nor does he grieve my heart.

Sa'am plants are in it,
In the presence of which one feels oneself uplifted!
I am your darling sister,
I am to you like a bit of land,
With each shrub of grateful fragrance.
Lovely is the water-conduit in it,
Which your hand has dug,
While the north wind cooled us.
A beautiful place to wander,
Your hand in my hand,
My soul inspired
My heart in bliss,
Because we go together.
New wine it is, to hear your voice;
I live for hearing it.
To see you with each look,
Is better than eating and drinking.

Ta-'a-ti-plants are in it!
I take your garlands away,
When you come home drunk,
And when you are lying in your bed
When I touch your feet,
And children are in your.........

. .

I rise up rejoicing in the morning
Your nearness means to me health and strength.

George A. Barton, Archaeology and The Bible, 3rd Ed., (Philadelphia: American Sunday School, 1920)

The Story of the Wax Crocodile

Once upon a time a Pharaoh went towards the temple of the god Ptah. His counsellors and servants accompanied him. It chanced that he paid a visit to the villa of the chief scribe, behind which there was a garden with a stately summer house and a broad artificial lake. Among those who followed Pharaoh was a handsome youth, and the scribe's wife beheld him with love. Soon afterwards she sent gifts unto him, and they had secret meetings. They spent a day in the summer house, and feasted there, and in the evening the youth bathed in the lake. The chief butler then went to his master and informed him what had come to pass.

The scribe bade the servant to bring a certain magic box, and when he received it he made a small wax crocodile, over which he muttered a spell. He placed it in the hands of the butler, saying: "Cast this image into the lake behind the youth when next he bathes himself "

On another day, when the scribe dwelt with Pharaoh, the lovers were together in the summer house, and at eventide the youth went into the lake. The butler stole through the garden, and stealthily he cast into the water the wax image, which was immediately given life. It became a great crocodile that seized the youth suddenly and took him away.

Seven days passed, and then the scribe spoke to the Pharaoh regarding the wonder which had been done, and made request that His Majesty should accompany him to his villa. The Pharaoh did so, and when they both stood beside the lake in the garden the scribe spoke magic words, bidding the crocodile to appear. As he commanded, so did it do. The great reptile came out of the water carrying the youth in its jaws.

The scribe said: "Lo! it shall do whatever I command to be done."

Said the Pharaoh: "Bid the crocodile to return at once to the lake."

Ere he did that, the scribe touched it, and immediately it became a small image of wax again. The Pharaoh was filled with wonder, and the scribe related unto him all that had happened, while the youth stood waiting.

Said His Majesty unto the crocodile: "Seize the wrongdoer." The wax image was again given life, and, clutching the youth, leaped into the lake and disappeared. Nor was it ever seen after that.

Then Pharaoh gave command that the wife of the scribe should be seized. On the north side of the house she was bound to a stake and burned alive, and what remained of her was thrown into the Nile.

Such was the tale told by Khafra. Khufu was well pleased, and caused offerings of food and refreshment to be placed in the tombs of the Pharaoh and his wise servant.

The Wife and the Dolphin

A man was in the land of Egypt, a son of his father and mother[1], and to earn a living [he worked] as a sailor on a merchant ship that was making its way to the coast of cedars[2]. His wife's name was Shushuna[3]. Since she [did not have any children[4], she would go out in a reed boat[5] every morning to the teeth of the rock[6], and only return home in the evening[7].

A female slave who had been working in the house [of the master] since childhood, noticed the habit of the mistress [of the house]. One morning, she followed her mistress out to sea, hoping that she would earn her freedom if she had something to tell [the master of the house] about what her mistress was doing[8]. When she reached the rock, she tied up her boat and climbed on to the rock. From the top of the rock, she saw her mistress lying naked in the arms of a young, naked man at the edge, their feet in the water[9]. Upon seeing what she feared to see[10], she returned to her boat and rowed to the shore. From that day on, she concealed what she had seen and did not tell anyone about it.

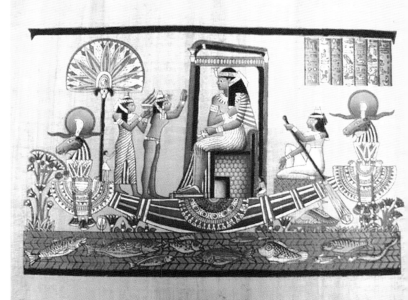

When the master's ship returned, the slave went to his room and whispered to him what she had

seen. Upon hearing her words, he beat her with a rod[11].

The next morning, when he opened his eyes, he saw that his wife's bed was empty. Remembering the slave's words, he took [his boat] and went out to sea. When he reached the tooth of rock, he tied up his boat and followed in the slave's footsteps[12]. When he looked at the water, he saw his wife, naked, as the slave had said, her feet in the water, and a dolphin with its tail in the water [lying] on her body, for it was the day of the god in which metamorphosis was not possible[13].

When the master returned home, the sun still high in the sky, he ordered the slave not to say anything to anybody, and gave her three coins.

When [his wife] returned in the evening, he said nothing to her.

Two days later, the master went out to the tooth of rock once again, and when he crept along the rock and looked down, he saw his wife in the arms of another man. In utter astonishment, he turned around and went home. In this way, he returned to the tooth of rock sixteen times, and each time saw his wife reveling[14] in the arms of the stranger. The seventeenth time[15], he took his sword[16] with him when he set out to sea.

When he climbed on to the rock, he did not follow his usual path [to the top of the rock], but crept between the bushes at the edge of the rock, where he waited, hidden from view, his sword in his hand.

Then, in front of his very eyes, face to face[17], his wife made love to the stranger. When the sun began to touch the surface of the sea, [the Egyptian] got to his feet and lifted his sword. As he was doing so, he saw the man slide into the dark water... and suddenly, right in front of him, he saw the dolphin leaping over the surface of the water, greeting the naked woman with a swish of his tail!

Like a stone statue, the Egyptian froze to the spot. The hand grasping the sword fell to his side. The naked woman put on her robe, pulled the rope[18], and got into her boat. Only late that night did the master return to his home, and, with the sword with which [he had planned] to kill his wife, he slit the slave's throat[19]. He never told anyone about what he had seen[20].

His wife gave birth to three sons, and during the birth of the third [son] she crossed the river21. Three days after her death, the fishermen found the body of a dolphin lying on the shore.

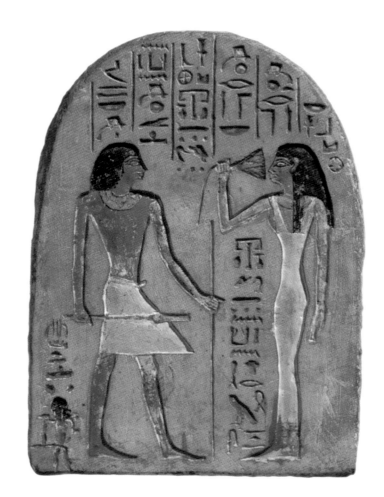

1 In other words, the respected son of a well-known family.
2 Today's Lebanon.
3 A well-known name in Assyria.
4 That is, free of the burdens of child-rearing and housekeeping.
5 A small boat made of reeds that was mainly used for sailing

on the Nile.

6 "Teeth of rock" is the name give to rocks that were placed in the sea at short intervals in order to prevent large enemy or pirate vessels from reaching the shore. This expression poses a certain problem. The Greek narrator attributes the story to the period between 1500 and 2000 BC, while teeth of rock were placed in the Mediterranean Sea only in the second century BC (their remains were uncovered in 1998 opposite the coast of Alexandria, for instance).

7 The definition of time, from morning to evening, points an accusing finger at the woman, as we will see later on. In ancient Egypt, adultery in broad daylight was more serious than adultery at night.

8 We find a great deal of evidence for the custom of granting slaves freedom in exchange for unusual services.

9 From the description, it seems that the slave climbed on to the tooth of rock and looked down on her mistress, who was on the lower edge of the rock.

10 This sentence is clearly ironic.

11 Since he did not believe what she was saying. However, the term "rod" indicates that this was a symbolic punishment (because the slave kept the secret and told no one but her master what she had seen).

12 Although this is not stated explicitly, it sounds as if the master took the slave with him as his guide.

13 The narrator explains to the reader why the slave saw a man while he saw a dolphin. The metamorphosis of an animal into a person or a person into an animal was common in ancient storytelling. The reader knows that there are times/places/conditions in which metamorphosis "does not occur" (the god's day). Another story in the same collection tells of a woman who turns into a goose in order to flee from a forced marriage, and is warned that "if she dips her beak in water, she will return to her original form". Of course, somebody throws a bucket of water over the goose at the critical moment, and she turns back into a woman.

14 The expression serves to intensify the woman's infidelity. It seems that she is not "just" making love with a stranger, but she is also enjoying what she is doing.

15 Apparently there is some mystical significance to this number.

16 Egyptian sailors carried a short sword and had to undergo combat training.

17 Perhaps it is worthwhile translating this as "belly to belly". The expression serves to stress that the woman was not copulating in the Egyptian way.

18 With which the boat was tied to the rock.

19 Because it was not possible to rely on the slave's silence for any length of time.

20 This sentence indicates the period in which there were prohibitions regarding women copulating with animals (among them dolphins). This is the reason why the date of the story has been set at some time between 1500 and 2000 BC.

21 The narrator uses the Greek expression for death.

Medical Papyri

Medical papyri such as this one, which is known as the Kahum Papyrus, provide a great deal of information about the position of the Egyptian woman thousands of years ago. According to the diseases from which the Egyptian women suffered, it is possible to surmise what their way of life was.

First, Egyptian women suffered from diseases of the digestive tract, including a tendency toward serious vomiting and diarrhea. Apparently, these diseases stemmed from the women's practice of eating the leftovers of the meal, after her husband and sons had eaten. In the extreme heat of Egypt, food that stood for a long time necessarily caused these phenomena. Men did not suffer from such problems.

Second, Egyptian women suffered from "female" problems such as: "the falling of the vaginal lips, incessant bleeding, a feeling of weakness in the back and thighs that stems from the vagina" and so on. The physicians of Egypt summed up these symptoms as a disease called "the fall of the womb." The detailed medical evidence, which is found in one of the papyri, advises the woman: "…to stand on her knees only with her husband and only when she wants to become pregnant ["standing on the knees" was the official sexual position in Egypt]; not to succumb to strangers and not to succumb to the customs of frivolous women who copulated with four-legged creatures and the crocodiles of the river."

In parallel, we find descriptions of men's "sexual" diseases, most of which are phenomena of impotence ("he dissolves like water when he comes to a woman," according to an Egyptian source) or the opposite – an erection that does not go down even after intercourse.

In addition, inflammatory diseases are mentioned: "And they look like red meat with lots of white dots in it…" The interesting thing is that the papyrus mentions that these diseases are transferred by

direct contagion during sexual relations. "My master went to the woman in the house of flowers and his member was as white as a marble column… My master returned from her and his flesh looked like red meat…" writes an Egyptian physician in his memoirs.

Egyptian medical papyri also knew how to advise women how to check whether they were pregnant,

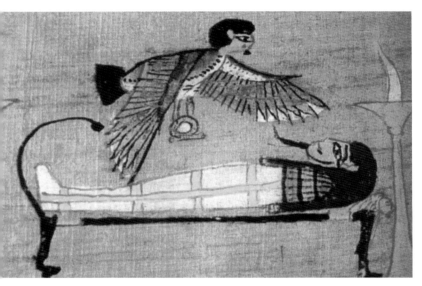

extremely important knowledge for any woman in Egypt. The Egyptians knew that human pregnancy lasted "nine moons" (that is, nine months according to the calendar that is based on the lunar cycle, involving 270 days. Since the men in the noble houses would keep an "intercourse journal" in which they wrote down who they had relations with and when, it was important that a woman's legal husband have relations with her nine months before she gave birth (and it did not matter which man impregnated her). Thus, women – especially ones who "played around" – would perform a simple urine test. They would urinate on a piece of fabric in which there were wheat and barley seeds, and the rule was simple: if both types of seed sprouted, the woman was pregnant. If only one type of seed sprouted, she had to do the test again. If neither seed sprouted, the woman was not pregnant.

There are papyri that also claim that if the wheat sprouted first, the woman was carrying a son in her womb, and if the barley sprouted first, she was carrying a daughter.

An Egyptian woman (like an Egyptian man) was forced to spend a fortune on perfumes and fragrant mixtures. The reason was, perhaps, the fact that Egyptian men and women practically did not wash their bodies. In the medical papyri, it is mentioned that after her period, a woman "will wash her hands and feet before coming to her husband." The fact that washing hands is mentioned as a "medical" action tells us that personal hygiene was not a top priority. An extract from an "erotic" Egyptian papyrus tells about an Egyptian maidservant who took her mistress' place below a deer that the lady had cultivated for her pleasure in the palace. The lady suspects and the maidservant denies, until the lady pulls the deer's droppings, and the maidservant immediately confesses to her sin and adds: "If I had gone to wash in the river, as I do every single month, my shame would not have been revealed to one and all!" With personal hygiene practices like that, it is quite clear why Egypt was an importer of fragrant perfumes from all over the world.

The ancient Egyptians were familiar with circumcision, and it seems to have been a common practice mainly among men of the priestly class. The circumcision was generally performed as a rite of manhood, when a boy became a youth (at approximately 12 or 13 years old). It is interesting that in addition to the priests, shepherds were also in the habit of circumcising their sons. Female circumcision was practiced in ancient Egypt, even though it seems that it was not the same as it is in Egypt today (namely, cutting off the clitoris in order to remove the areas that can lead to the woman being sexually stimulated and to committing adultery), but rather by

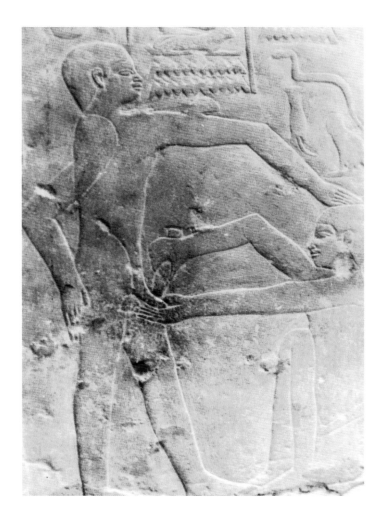

piercing a hole in the hymen. There is a wall painting that depicts a girl being held by two women, her legs apart, and a third woman holding a thorn kneeling in front of her. Apparently, this thorn was used to pierce the hymen – not in order to make things easier for the man, but to release "bad blood" (menstrual blood). The circumcision of the woman took place at about 10 years old. We also know about circumcision that was performed in Sudan (south of Egypt) and still exists to this day, in which the clitoris is cut along its length so that a forked "tongue" like a snake's is created. This cut is called "the image of a viper" in the Egyptian writings, and its purpose is to increase passion. (Today, however, even though it is mainly male circumcision that is accepted, especially in the West, it must be remembered that in countries such as Egypt, there is at least one woman in about 85% of families who has undergone circumcision in the form of cutting off the clitoris or the small inner labia at the entrance to the vagina. In a study that was conducted at Cairo University, 65% of the female students who were natives of Cairo declared that they had been circumcised!).

The well-known picture entitled "Nut and Geb" – the goddess of heaven and the god of earth (who was also her brother) – is important for understanding Egyptian eroticism and the image of the man and the woman in Egyptian culture, and for defining the "threshold of modesty" that prevailed in ancient Egyptian society. In many classic cultures, heaven was considered to be "male" and earth was considered to be "female," and so the basic positions dictated that the man be "on top" and the woman "underneath." In ancient Egyptian society, this limitation did not exist and therefore there was an enormous range of sexual positions.

The "reed" (the penis) was as long as the god's thigh, and this picture constituted a yardstick for the Egyptian male's masculinity. Owing to the influence of this picture and other similar ones of Nut and Geb, the "reed" in erotic pictures was gigantic in size... and determined the ideal of Egyptian masculine beauty that was difficult for many Egyptians to deal with. In cultures that preceded that of ancient Egypt, as well as in cultures that flourished in parallel, the ideal woman was short with a broad pelvis and large breasts –

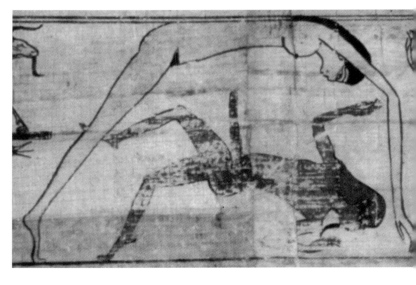

characteristics that attested to the woman's "role" of giving birth. In this picture, we see a different ideal – the woman is taller than the man, thin, and has nice but not large breasts. It is clear that this ideal image was also reflected in the Egyptian erotic pictures.

Finally, the very fact that the god and the goddess appear totally naked, without any covering whatsoever, their genitals prominent, contributed a great deal to the openness we find in the literature, poetry, and erotic art of ancient Egypt.

The youth's words:

[My] sister is one of a kind. There is none as beautiful as she

[Among] all women

She is liken the rising Sutis

At the beginning of the blessed year:

Shining, precious, white of skin,

Her eyes are beautiful when she gazes.

Sweet is her lip when she speaks,

And there are no unnecessary words with her.

Long of neck, white of bosom,

Her hair a true blue stone.

Her arm is superior to gold,

Her fingers are like the flower of the lily.

Soft of buttocks, tight of waist –
Her thighs complete [?] her beauty.
Handsome when she walks over the ground
With her embrace she captures my heart.
She turns the heads of all the men
When they see her.
Happy is anyone who embraces her
He is like the first of the lovers.
When she goes outside she looks
Like that one, the only one, [going out].

The girl's words:
My brother stirs my heart with his voice
And makes me ill.
Here he is, close to my mother's house.

I cannot go to him.
My mother is right when she orders me so:
Avoid seeing [him].
[But] my heart is upset when it remembers him
Since love made me its captive.
He is like a heartless person –
And like him, I too will live!
He does not know my yearning to embrace him –
Otherwise he would send [a message] to my mother.
Oh, my brother, I command you
With the hands of the golden goddess.
Come to me and I shall gaze upon your beauty!
May my father and my mother be joyful,
And everyone will be joyous together with you,
They will be joyous with you, my brother.

Love Poem

Oh! when my lady comes,
And I with love behold her,
I take her to my beating heart
And in my arms enfold her;
My heart is filled with joy divine
For I am hers and she is mine.

Oh when her soft embraces
Do give my love completeness,
The perfumes of Kemet
Anoint me with their sweetness:
And when her lips are pressed to mine
I am made drunk and need no wine.

Splendour that was Egypt - By Maragret A Murray

So beautiful is the queen

Pristine are her limbs like sea foam

Her smile lights up the heart [of the observer]

Her eyes send jets of fire

Her bed is like the lotus pool[1]

And the fragrance of her body is like the smell [of life?].

So beautiful is the queen

And why does the [man] Pharaoh

Brother[2] to the queen and ruler of the river

Pursue the bottoms of white youths?

Has not the queen a bottom?

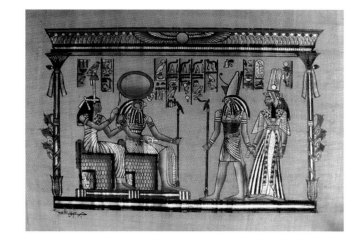

This is an extract from a papyrus that was found only in a French translation in the notes of the Napoleonic delegation to Egypt. An adjoining sheet of paper dates it to approximately 1750 BC, and mentions the name Senuserets [a pharaoh belonging to the 12th dynasty, known for the fact that a female pharaoh ruled after him]. The extract was found in a writing box in which "unreliable" reports were kept – the members of the delegation received payments and bonuses for the findings they wrote down: the more numerous the findings, the higher the pay.

1 An expression that meant "full of sexual desires."
2 Brother in the sense of husband.

Phallic Worship

Phallic worship is a prominent characteristic of the Egyptian culture. George Ryley Scott, who wrote the book *Phallic Worship* and was considered to be an expert in the ancient Egyptian culture, claims that phallic worship originated in the Osiris ritual, which began in Egypt and spread in various forms all over the world.

We know that Osiris was also worshiped in the image of the bull (which can change its image to that of a person) and in the ancient world the bull was considered to be unequalled in its potency and to have a gigantic phallus.

In this context, it should be mentioned that in the Egyptian erotic writings, the bull is described as the largest creature, from both the points of view of its weight and of the size of its penis, which can copulate with a woman. This context also appears in Greek and other myths. Plutarch describes the statue of Osiris and focuses on the prominent penis. Osiris is the embodiment of the male principle just as Isis is the embodiment of the female principle.

The special thing about the Egyptian phallic ritual is the power that motivates the proce – Isis. Osiris' brother murdered him, dismembered him and distributed his body parts in various places. Isis succeeded in collecting all the parts… except for the phallus, which had been thrown into the River Nile – a well-known motif in the Mediterranean myths, which appears almost in the same form with the Phoenician god, Camillus. Isis ordered the priests to build statues of Osiris in which the missing member – the phallus – was prominent. Moreover, she instructed the priests to choose the virile bull as the animal that would symbolize Osiris.

Diodorus Siculus recounts that on Isis' orders, people began to adore and worship Osiris' erect phallus, which was conspicuous in every temple, and this ritual won the hearts of the masses. The Greeks are the ones who copied the Osiris ritual under the name of Dionysus, and called the penis a phallus.

Diodorus goes on to say that Osiris was the god of the sun, of the River Nile and of fecundity in nature – he symbolized all those with his erect member. According to him, the women of Egypt wore amulets or ornaments in the shape of Osiris with the erect phallus, usually near their girdles and hidden beneath their tunics. Various religious processions featured statues of Osiris that were equipped with especially large phalluses for the occasion.

R. Payne Knight, another expert who wrote *Worship of Priapus*, mentions that the Egyptians believed that "the bigger, the better," and in order to indicate overflowing fertility, they equipped Osiris with an enormous phallus. The Greeks, on the other hand, who also believed in fertility rites linked to the phallus, equipped their gods with much more modest members.

Phallic worship is expressed not only in statues and paintings. In many cases, men served as "statues," and they were carried in religious processions or placed on stands in temples, naked, sometimes with a fake phallus on their bodies and sometimes equipped only with what nature had given them.

"And many women, whose bellies had not been blessed by nature, run after these Santos and kiss their priapus, and if they can, they rub the member on their belly. And among the Santos, there are those who tie round stones [to their members], and the women try to catch the member in their mouths and detach the string [that is tied to it] in their teeth, in the belief that the stone will become [a baby] in their belly."

This is what De Thevenot writes in his book about his travels to the Levant, including Egypt, in 1687. The Santos are the men who assume the image of Osiris. It seems that in that area, the Egyptians preserved the ancient ritual customs for thousands of years. The essence of these customs is represented by a poem from 1800 BC:

Carried on the shoulders of eight [men]

A noble and handsome man…

…I ran in the crowd, I climbed [onto the stand]

I kissed

The person in the image [of Osiris]

…I ran to my brother, to my love,

when I was Isis…

The lines of this poem are incomplete and any hint of a sexual act has been expunged from them. Nevertheless, the general picture is still clear.

As a result of phallic worship, which was expressed among other things in the worship of the bull, Isis was venerated as a cow after her death. The cow is the suitable partner for the phallus/bull/Osiris, and Thomas Inman mentioned that in the ancient world, the cow was considered to be a sexual creature overflowing with passion. "Like a cow yearning for a bull" is an Egyptian expression that indicates a woman in the clutches of desire. Over the years, the image of a cow became the image of a woman with cow's horns who is exposing her gaping vagina. Women participated in the processions in which statues or men with erect phalluses were carried as a symbol of fertility. They were sometimes naked and wore cow's horns and carried a sistrum [a wire rattle]. The sound of the sistrum was considered to be "a melody that can bring the phallus to life," according to Hannay, an ancient art researcher.

Many researchers think that a cow, cow's horns, cow's eyes or a cow suckling a calf symbolize

phallic worship that originated in ancient Egypt in the form of the female principle. Thus, according to James Gardner, Astarte has cow's horns and cow's eyes, and Venus suckles a calf. As mentioned previously, all these myths originate in the phallic ritual that is reflected in the tale of Osiris and Isis.

It is interesting that in ancient Egypt we also find secondary phallic gods who serve as "backup" for Osiris. The most famous among them is Khem, about whom it is said that "one thousand temples were built in his honor" and the "every flowering garden is his place."

As early as 1837, J. G. Wilkinson mentioned that Khem is actually the god of "reproduction" and fertility and that he is in charge of "preserving the existence" of every species in the world, together with the female identity, maut (the sound of this word is preserved in the word "mother"). Khem was worshiped in the form of a he-goat, and his rituals were full of lasciviousness. Later on, he assumed the form of Pan in the Greek ritual. Both Strabo and Diadorus – two authoritative researchers of Egyptian customs in the ancient world – considered the Khem rituals to be the pinnacle of the possible ritual sexual "corruption."

Another well-known researcher, Bunsen, pointed out in 1848 that an entire Egyptian dynasty of gods is actually based on a "phallus", a phallus that turned into a god. Ammon, the creative god, who appears as the creative force in the image of Khem, the person who merges the image of Ammon-Ra, whose image was symbolized by Kneph, who sent Min to serve as his representative. This entire dynasty of gods shows how powerful the phallic ritual in Egypt was.

The interesting thing about the Egyptian phallic ritual lies in the fact that its customs survived for thousands of years, not only in the form of statues or paintings that represent a phallus, but also in ceremonial customs. The phallic ritual is expressed in ancient Egypt in sexual processions, in orgies and in bull rituals. Researchers such as Thevenot (1687) or John Lewis Burckharet (1830) found similar customs in their research, and claimed that these customs, which they had observed first-hand, were "remnants" or "echoes" of the ancient Egyptian customs that Eusebius, Strabo and

Diodorus had written about, and that the aim of these customs, then and now, was phallic worship and ritual.

"Abomination is in the eye of the beholder and abomination is in the ear of the hearer, for the pleasure-mongering Egyptians are in the habit of hiring a broad river barge and loading it with whores, female and male, and sailing it along the Nile. And when they approach a settlement, the women expose their breasts and groins, and the men reveal their groins, and they shout lewd things to the inhabitants of the place and invite them to come and enjoy the fruits of their whoredom… And there are those [among the Nile inhabitants] who place their daughters and sons in front of the boat, and try to sell them to the pleasure-mongerers. All this I saw with my own eyes and heard with my own ears. And there were those who told me that on certain festivals, men and women are in the habit of copulating openly on the deck, to the joy of the spectators on the banks of the river… And sometimes they bring with them white-skinned and golden-haired maidservants, and after they have sailed along the river, they sell them along the Nile in a black land [in the land of the blacks], because their price is high there and gold is cheap…"

(An author from the third century BC. His name was Dioparos "the Bearded" and he is mentioned as "the Greek traveler.")

Herodotus Journey to Ancient Egypt

Herodotus, who was called the father of history, was in fact also an amateur anthropologist, and his history books are full of tall stories (Cicero called them fabulae, seeking to stress that Herodotus was

attempting to explain phenomena and concepts by using "fables" that he made up). It appears that he was born in 485 BC in Halicarnassus in Asia Minor (today's Turkey), and from 460 to 420 (apparently) he undertook various journeys to the neighboring Mediterranean countries. His work, *Historia*, has survived in its entirety to this day, and the second book in it, which is devoted to ancient Egypt (as is the beginning of the third book) reveals important facts about that kingdom. Herodotus is the only written source for some of these facts. As is his custom, Herodotus also writes about the sexual habits he learned about in connection with ancient Egypt, and that is why he is very important. However, he does not go into detail, nor does he examine the information he received in a practical way.

Herodotus determines that in Egypt, "the women engage in buying and selling, while the men sit at home and weave" (Book 2: 3). "The women urinate standing up while the men kneel down" (ibid. – there is verification for this in Egyptian wall paintings). "The Egyptians live with their cattle" (Book 2: 63). "They are the only ones who perform circumcision" (ibid.). "Every man has two items of clothing, every woman only has one" (ibid.). Herodotus praises (37) the extent of the Egyptians' cleanliness: they wear clean clothes,

circumcise themselves for reasons of hygiene, the priests shave their bodies every two days and they bathe in cold water four times a day. These testimonies are contradicted by later testimonies that state that the Egyptians, especially the women, refrain from bathing and "cover their stench in jets of perfumed water."

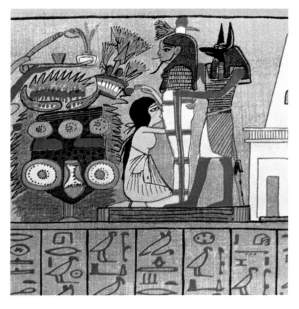

From chapter 48 onwards, Herodotus describes the worship of Alis, the male organ. In the festival dedicated to Dionysos (in Egypt), the Egyptians carry dolls with a swaying penis as long as the entire doll. These dolls are carried by women in huge processions headed by a male flautist. We must bear in mind that Dionysos is the same as Osiris, and that Osiris was attacked by Seth in the form of a pig. Isis gathered up Osiris' organs – all except the phallus. Thus, during this festival, the lost phallus is eaten in a ritual or actual act of copulation with the dolls' penises (Herodotus refrains from describing the latter part of the ceremony). According to him, the Greeks learned phallus-worship and the use of the phallus in ceremonies, statues and religious processions from the Egyptians.

In chapter 48, Herodotus makes casual mention of something he heard about Egypt – a woman who openly copulated with a ram. Taking into account the existing testimonies to the fact that women in Egypt copulated openly with rams, horses, donkeys, bulls and so on – both in religious rituals and for purposes of pleasure or sex shows – it seems that Herodotus somewhat underestimates its importance, and considers it to be despicable. This is in spite of the fact that the Greek mythology with which he was very familiar is full of stories of couplings between gods who assumed the shapes of animals of various kinds in order to copulate with beautiful women.

In chapter 57, Herodotus says that "the dove was black and so the woman was Egyptian." Throughout his commentary, it transpires that he considers the Egyptian women to be dark-skinned or black.

In chapter 60, Herodotus describes: "... The following are the proceedings on occasion of the assembly at Bubastis: Men and women come sailing all together, vast numbers in each boat, many of the women with castanets, which they strike, while some of the men pipe during the whole time of the voyage; the remainder of the voyagers, male and female, sing the while, and make a clapping with their hands. When they arrive opposite any of the towns upon the banks of the stream, they approach the shore, and, while some of the women continue to play and sing, others call aloud to the females of the place and load them with abuse, while a certain number dance, and some standing up uncover themselves. After proceeding in this way all along the river-course, they reach Bubastis, where they celebrate the feast with abundant sacrifices. More grape-wine is consumed at this festival than in all the rest of the year

besides. The number of those who attend, counting only the men and women and omitting the children, amounts, according to the native reports, to seven hundred thousand."

The History of Herodotus. Written 440 BC. Translated by George Rawlinson

... and one of the women[1] [whose husband had died upon her] approached the priests, and with a large bribe bought her way [to the embalming room], and when she lay down on the [embalming] bed, she covered her body with a shroud and looked like a corpse. And so the hours passed, and when she was alone, she hurried to take the lamp [from the wall] and found the body of her husband lying on the board with his member still[2] on him, erect as a spear. And when she saw her beloved husband, she rushed to climb on his body and satisfy her love for him, and when she got off his body, his member was flaccid[3] (like the chochou[4] leaf). And afterwards, weeping for her husband, she quickly crept back home. Nine months past [their cycle] in the sky, and she gave birth to her son, and when she saw him, she cried out loud:

I had many priests,
They ploughed and watered my flowerbed,
My one husband was planted in my vagina
And the liquid of his semen in me...[5]

For this reason, the Egyptians claim that a woman can have as much sex with men as she wants, but only the man she loves will fertilize her womb[6].

1 The story is the continuation of a battle scene in which many Egyptian warriors were killed.
2 During the embalming process, the penis and testicles were sometimes cut off and embalmed separately in a long box.
3 While priests would have intercourse with women's corpses (necrophilia) as if they were alive, the ritual intercourse with men would take place after an artificial penis made of wood or a precious metal had been placed on the man's corpse. The women would have sex with this penis, which was never flaccid. The repeated stress here serves to emphasize that the penis in this case is "flesh and blood."
4 Probably an aquatic plant we do not know.
5 Apparently, the song had eight more lines that were lost.
6 As far as we know, this "fact" only appears here.

A Woman's Lost Love

Lost! Lost! Lost! O lost my love to me!

He passes by my house, nor turns his head,

I deck myself with care; he does not see.

He loves me not. Would God that I were dead!

God! God! God! O Amun, great of might!

My sacrifice and prayers, are they in vain?

I offer to thee all that can delight,

Hear thou my cry and bring my love again.

Sweet, sweet, sweet as honey in my mouth,

His kisses on my lips, my breast, my hair;

But now my heart is as the sun-scorched South,

Where lie the fields deserted, grey and bare.

Come! Come! Come! And kiss me when I die,

For life, compelling life, is in thy breath;

And at that kiss, though in the tomb I lie,

I will arise and break the bands of Death.

Splendour that was Egypt - By Maragret A Murray

Harems

The kings of Egypt, the pharaohs, kept harems containing hundreds of women. These women were Egyptians (including members of the king's family) and foreigners. The kings of Egypt would bring women from various countries to their harems, and the sexual ties actually constituted the cement for political or economic alliances. It is no wonder that one of the pharaoh's names was "the highly potent bull" – a pharaoh who could not have intercourse with all the women of his harem was well on the way to losing his throne. When the kings of Persia or the kings of the islands in the Mediterranean Sea sent the Egyptian king a gift of hundreds of gorgeous women [to the harem], it was not only to seal an alliance, since the inability to have intercourse with the tens and hundreds of women could effect extremely significant political changes. It is no wonder that we find an inscription in a tomb that reads, "…The dead man… in the guise of the king… came to his women and fulfilled his duties…" It would appear that the king of Egypt employed stand-ins who looked like him to carry out his sexual duties.

The kings of Egypt kept harems all over Egypt, and they were all supervised by the queen, who was assisted by the priests. Sometimes the harems housed over one thousand "wives" (who were in some kind of married or couple relationship with the king), and ten thousand male and female servants. There were no eunuchs in the Egyptian harem. All of the women's offspring – from first-, second- or third-degree relationships to the king – were considered to be royal offspring, but the heirs to the throne were usually only the offspring of the "Egyptian" women – generally women who were somehow related by blood to the king (such as sisters, for instance). There were pharaohs (such as Rameses II) about whom it was written that they were "…begetters of ten thousand offspring…"

During certain periods, harem life was full of plots and disputes. It is also well known that pharaohs such as Amenemhet I and Pepi I lost their lives while indulging in the pleasures of the harem, while Rameses III fled naked and bleeding from the harem in order to save his skin. This is perhaps the reason why in later periods, the kings of Egypt reduced the extent of their lust to one queen and a small number of second-degree wives.

In several sources, King Solomon (who boasted 700 wives and 300 concubines) is called "the king whose appetites were like the appetites of Egypt" or "the Egyptian king." There is no doubt that his large harem was an imitation of the Egyptian custom of his time.

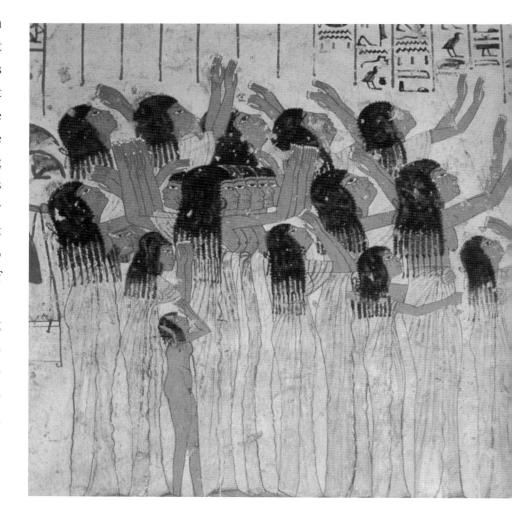

The 8 Elements for a Good Sex Life

In the next passage, which is very disjointed, lists the known positions, calling them "the 8 elements for a good sex life," even though in fact there are many more than 8 positions. According to a conservative estimate, the full papyrus contained some 45 different descriptions. The papyrus dates from the 16th century BC, and it is in the possession of a private collector in Cairo.

1. "The woman who dreams that she kneels down and the man is [behind her] … a dream… stands as if kneeling… good things will come to her… stands [behind her]… and her house will be full… and if he [the man] falls on her back, she will have difficult days."

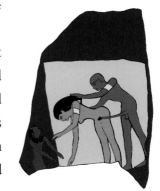

This extract was much longer. It describes the most widespread position in ancient Egypt, which was called "the grinding position" – the woman kneels down and grinds grains of wheat with a stone. The man gets down on his knees behind her and penetrates her from behind while leaning on her bottom or her back with his hands (similar to the position in which she leans on the stone). Variations on this position are possible, but the basic rule states that the man's back is vertical all the time, and the woman's back is horizontal.

2. "The woman who dreams that she is a goddess of the heavens and inverts her deeds [inverts her position] and [the man] is like a cloud [that is, above her], will be loved by her husband… And if she [dreams] that [the man] gets down and is like a god [the earth], evil will befall one [of her sons]…"

This extract describes the position that was called "the dancer's position". The Egyptian creation epic

describes the female goddess as a rainbow in the sky, her face, breasts, belly and groin turned toward the earth. The dancer's position switches the direction and the man, instead of lying on his back and waiting to be serviced, finds himself on the female's body without being in contact with the earth.

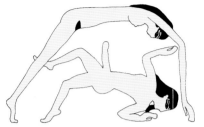

3. "The woman who dreams that she is lying like the god [the earth] and her legs are in the air, will keep strict control of her [household]…"

This position is known by the name "heaven and earth" in which, the man lies on his back with the woman on top of him.

4. "The woman who dreams that she lifts her leg [one leg]… there will be a quarrel between her and…"

This is the position known as "the stork" in which the woman stands and lifts one leg into the air.

5. "The woman who dreams that she is in the arms [of her lover] with her legs on his shoulders… a great deal of wealth will come to her home…"

This is the position known as "the lovers' stand" – the man stands on his feet and carries the woman in his arms, with her legs on his shoulders. In a certain variation, the woman can sit on a high chair in order to make it easier for the man.

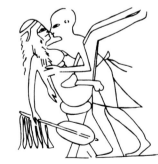

6. "The woman who dreams that she turns her [bottom] toward her lover, and looks at him [from below], a crisis will come between her and her husband and she will be somebody else's."

This is the position known as "she who bends down" and it is actually a variation of the "grinding position", with the woman standing and bending her head.

7. "The woman who dreams that she is sitting with her face toward her lover, will give birth to a son..."

This is the position known as "she who sits in [her lover's] lap", and it is based on sitting face to face with the woman's legs over the man's legs.

8. "The woman who dreams that she is sitting [in her lover's lap] facing away from him... another woman will find [her lover]..."

This is the position known as "she who sits with her back [to the man]".

As we mentioned above, we can estimate that some 45 different positions were described in the papyrus, but only 8 of them can be clearly identified.

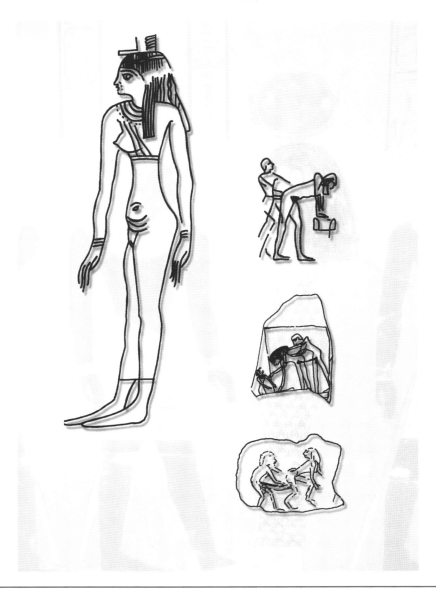

This is a poem from the 17th century BC that was first translated into German by Rappoport in 1868. Here is the English translation:

Black am I,
Even the waters of the river will not purify it[1].
My body is like a sieve[2],
Black is my hair,
Everyone who had me
Mine, he is mine,
Like a thousand, like ten thousand men

The desert sun has bronzed my skin,
My clothes are in tatters,
It has known countless men.
Many are the beads in it,
Left me a bead[3].
One man is my beloved,
My beloved will be to me.

1 The meaning of the poem does not refer to the girl's origin (Sudanese?) but rather to the fact that she is a "wild girl". Egyptian girls took care not to become sunburned in the hot sun, and we often see paintings that feature sunshades, awnings or clothing that protected their bodies from the sun.

2 The sieve refers to the implement used for sorting grains. The meaning here is that while many men had possessed her, none of them had left his "mark" on her. Many Egyptian poems contain seemingly "crude" expressions such as "open", "a bottomless hole" or "a jar whose seal has been broken" in order to indicate a woman who has lost her innocence. The use of the term "sieve" here is particularly unique.

3 In a later period, from the fifth century BC to the first century AD, Egyptian prostitutes (who were mostly Hellenistic or Macedonian in origin) would weave beads into their hair or belts in accordance with the number of clients they had served. This was considered to be an advertisement for their skills. During certain periods, decrees were issued prohibiting prostitutes from adorning themselves with beads that they had not earned honestly…

Animal pictures

In remnants of Egyptian papyri, "animal pictures" are frequently mentioned in sexual and erotic contexts. "Animal pictures" were in fact sex manuals that were divided into two types:

The first presented paintings or etchings of mating animals. The reader or observer was required to force his imagination to adopt the "way of the animals," as is stated in the ancient Egyptian papyrus remnant that features part of a love song:

The second was much more interesting. It consisted of paintings of different kinds of animals mating with one another, including pictures of men and women copulating with animals. According to the written descriptions of the "animal pictures," the positions shown were the positions that were popular with human beings. These papyri were manuals that were intended for people who were aficionados of erotic variety.

Unfortunately, these papyri were virtually all destroyed, and even in places where they survived, the "delicate bits" were excised. The fact that they were widespread and popular can be seen in the papyrus that presents pictures of animals engaged in human actions – a board game, cattle herding, and so on – and for dessert we see a "dirty" picture of a lion mating happily, his partner stretched out on the table in front of him.

Ancient Egyptian Customs

In the biblical book of Ezekiel [16:4], one of the Egyptian customs for "enhancing" natural beauty is mentioned. The Bible states: "...thou wast not salted at all", which refers to the ritual in which infants' bodies were rubbed with salt water. This ritual was widespread along the shores of the Mediterranean Sea, mainly for females but also for males in certain places. The Egyptian belief stated that rubbing with salt water had a purifying effect, and the baby girl would be protected against the evil eye.

An anonymous Greek writer from the first century BC tells about the custom of the young Egyptian women: "They immerse themselves in the salt water and scrub their bodies with a salty stone before they go to the men. And they believe that the touch of their (salty) body will bind the man to them forever more. And there are some who place salt in jars of wine, and wash their bodies with the salty wine."

The same chapter in the book of Ezekiel describes two ancient Egyptian customs. Verses 6-8 relate the story of a baby girl who was found in a field and raised by a stranger. The Egyptian custom was to place infants that had been born to unmarried women, or to women from poor families, on the bank of the river. In most cases, the infants were taken and raised as legal offspring in foster families (remember, for example, the life history of Moses). In verse 7, the baby girl grew up, and she appears before the man as "...come to excellent ornaments". In the original Hebrew, this refers to the most beautiful jewel of all – full nudity! The little girl's body has become a woman's body, and this sight is more beautiful than any jewel! Further on in the verse, the following description appears: "...thy breasts are fashioned, and thine hair is grown, whereas thou wast naked and bare". The appearance of breasts and the growth of pubic hair (called "the hair of the feet" in Isaiah 7:20, and

pronounced "sha'ar" in Hebrew, that is, the opening between the legs) were signs of sexual maturity. Thus, the man who took her to his home hastens to assert that "thy time was the time of love" – in other words, she is now ripe for copulation. He immediately covers her nakedness (by giving her a garment) and has intercourse with her. Later on in the chapter, after the sexual act and the spilling of the blood of virginity, the girl/woman is rewarded with fancy clothing, with a massage with oil, with gold and silver jewelry, and with various delicacies that increase her sexual desire (semolina, honey and oil).

The continuation of the chapter describes the reversal of the wheel of fate. The girl, who has become a happy woman, bestows her favors on every man. In other words, she becomes a prostitute. From the beautiful clothes her "savior" – the man who found her – gave her, she prepares "images of men" – male genitals that were used both as idols and for satisfying sexual needs.

"Sex Games"

In a manuscript that is kept in the Egyptian Library, Abdel Magid ubm Abi Sulaiman, who lived in the 11th century AD, wrote a serious indictment against ancient Egyptian society for creating a class of women/prostitutes who were completely devoid of family ties. This class, according to him, still existed in his own times. "There is nothing new under the sun. Our streets are full of prostitutes who mince in front of every man [the writer uses the word salmakides, the Greek name for a prostitute, which, from a linguistic point of view, means "one who sways her buttocks when she walks"], and day-old baby girls are sold for a farthing… because we have learned from the customs of the ancient Egyptians. The latter were in the habit of raising the girls [the writer uses the Arabic expression that actually means "before the age of circumcision"; in Egypt at that time, it was customary to circumcise boys and girls between the ages of 11 and 13] in their homes, giving them food and drink, until they discovered the signs of womanhood in the girls, and then they would have intercourse with them – they themselves or members of their family. And when they were tired of them, or when their virility had waned, they would banish them from their homes, and that is how the woman/prostitute class was created. Their whole lives they were raised for prostitution, and they do not know [how to do] anything else…"

We are well acquainted with the Egyptian custom of "nudity before adolescence" in both girls and boys (who wore a short garment that was open in the front). We find many testimonies to the existence of "sex games" among children and between adults and young girls – sex games in which full penetration did not take place, but the ejaculation of semen did. In various paintings, we see that the little girls are naked and adolescent girls (who are differentiated by rounded breasts and a shadow of

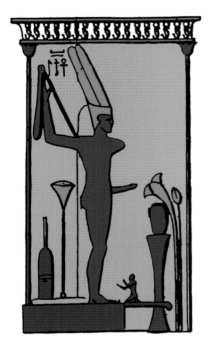

pubic hair) are covered with a garment. However, there are few testimonies to a "class" of women who were raised from childhood to be providers of sexual services, and most of them do not come from direct Egyptian sources.

During the second half of the first century BC, the Romans detested the Egyptians. The Romans came and stole gold and wheat from the Egyptians, fought them for control of the eastern shores of the Mediterranean Sea and the islands, and were furious that two of their revered leaders, Julius and Antony, fell under the spell of the Egyptian queen, Cleopatra. In retaliation, various tales were written in Rome, some of which were factual but most of which were imaginary. A large number of these stories dealt with the sexuality of the Egyptians. An excerpt from an unknown writer, Catoulos "the naughty" – evidently the nickname of someone who opted not to publicize his name – tells us:

"So great is the corruption of [the Egyptians] that they abduct day-old infant girls – females only – from their mothers' arms, and they even take "sword-babies"[1]... and raise the little girls like pigs[2] in the yard of their house, and anyone who feels so inclined can lay hands on them. And they have beliefs about lying with men [homosexuality] and other beliefs about lying with animals [bestiality]... And when [these girls] grow up, before they have... [missing text]... and they

flaunt their skills in front of everyone, and bring the coins to their masters. And when the women [become old] and nobody desires them, the master removes their jewels and their clothes and throws them [the women] into the river [Nile], food for the crocodiles that inhabit its waters."3

1 The female infant of a pregnant woman who was killed and had her belly slit open, revealing a living baby girl. This was a repulsive custom of the Romans, who habitually killed their enemies' pregnant women and slaughtered the fetuses. We do not know whether this custom was prevalent in ancient Egypt.

2 The pig was actually a holy animal in Egypt – only priests were permitted to eat its flesh (except for one day a year, when everyone could eat it). The anonymous writer describes the Egyptians without knowing their customs.

3 There is no Egyptian evidence of this custom.

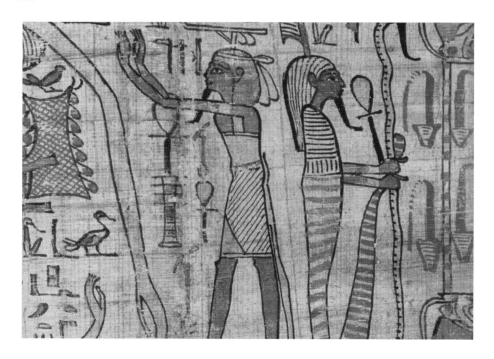

How beautiful is my beloved,
Deep are her eyes as the waters of the well[1],
Black are her eyes as the black of the night,
But when she looks at me,
Her eyes are illuminated with the light of the god[2].

How beautiful is my beloved's hair,
Black it is as the tree that comes from Nov[3],
Like a jewel it hangs on her forehead,
And when the evening wind blows it,
It flutters like the wings of a bird
That brings joy to my heart.

How beautiful is my beloved's face
When it is reflected in the waters of the river,
They hide her white face,
For the king[4] she covers her face[5],
Only for me does she reveal her beauty.
How beautiful is my beloved's body,
Rising as the palm tree to the high goddess[6],
Full are her breasts as the breasts of a nursing woman[7],

Round is her belly as the sun[8] during its birth,
And her legs are as beautiful as the legs of a deer[9].
How beautiful is my beloved's body,
In her white robe adorned with jewels[10].

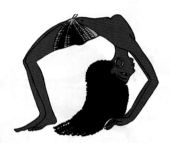

1 A common expression mainly in Phoenician literature.

2 The name of the god is not mentioned, but it can be assumed that the reference is to Horus.

3 Nov, or Africa (the land south of Egypt).

4 "The wearer of the crown", meaning Pharaoh or one of his governors.

5 He is afraid that the king might desire her.

6 The goddess of the sky.

7 In many cultures, including, apparently, the Egyptian culture, the breasts of nursing women are thought to be an erotic element of the first order.

8 An expression apparently taken from the literature of ancient Babylon.

9 A comparison that appears in many sources, including the Bible. The deer was common in Egypt and the Mediterranean Basin.

10 A love song whose Egyptian source has been lost, but translations of it exist in Greek, Aramaic and even in Sanskrit. We have reconstructed the Egyptian source by comparing it with the Greek and Aramaic translations.

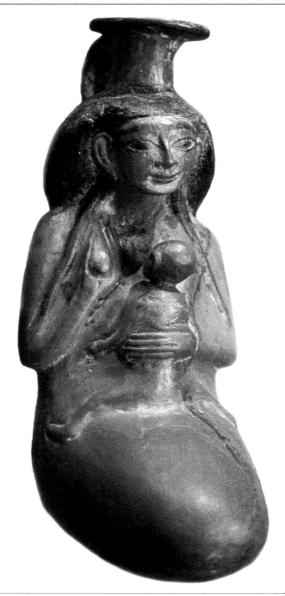

An excerpt from a Roman story
[dating from the first century BC]

"They [the Egyptians] are in the habit of anointing their bodies with perfumes and fragrant oils, and coming to one another in the dead of night. There was a case in which a young man fell in love with his neighbor's daughter, and she, after assenting with her eyes, left her door open. In the dead of night, the youth came to the bed of his neighbor's beautiful daughter, and the smell of the perfume that rose from her body inflamed his senses, and he slaked his passion in her body until the morning light. When dawn broke, he saw her face, and horror seized him... It was not the neighbor's beautiful daughter that was with him [in the bed] but rather a slave[1] with an ugly face and wrinkled skin. For in the dead of night, when she spread her lady's perfume over her body, the slave turned into his heart's desire..."

At this point, the neighbor bursts into the room and accuses the youth of raping the slave. In order to avoid a trial, the youth marries the slave. "...And only one thing did he demand – that her lady give her her share of her perfumes and cosmetics."

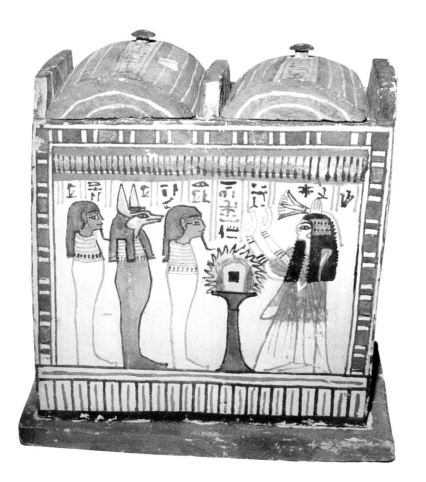

The youth and his young wife flee the city in disgrace and establish their home "at the edge of the desert". Some time later, the slave dies and the youth returns to his city and finds that his neighbor has died and that his daughter is living in poverty and misery, "and the smell of her body is like the smell of mud"[2]. He removes the rest of the perfume from its containers, anoints her body... and falls in love with her on the spot. And then, of course, they get married and live happily ever after.

1 The rank of a female slave was different from that of a male slave. Her honor had to be respected and her offspring were considered to be members of the family. The master of the house had to marry her off if he did not use her as a concubine.

2 Mud is the substance from which bricks were made. In order to strengthen it, straw and animal droppings were mixed into it.

Cinderella – Ancient Egyptian Style!

This ostensibly innocent Egyptian story recounts better than any papyrus the story of the problematic nature of collecting and preserving the material regarding ancient Egyptian eroticism. The papyrus itself was found some time prior to 1801, the year in which a chest containing other papyri and small works of art arrived in Paris, and fell into the hands of an art dealer of Greek origin who signed his name as S. Yanno. We can only estimate that the papyrus was written between the 11th and 14th centuries BC. Evidently, the entire chest was catalogued by an expert, since when it reached Vienna in 1832, it was accompanied by a detailed list that had been copied by an unknown clerk. The papyrus under discussion bears the number 14-677193, a number that has no scientific meaning. Between 1832 and 1835, the contents of the chest were sold to various buyers, and some of the details of the sales were indicated on the back of the inventory list that was preserved. Alongside the papyrus was written, "Complete papyrus. The search for … a picture of a naked woman in red. Sold in two parts to J. B. Walsergay." It seems as if someone had attempted to decipher what was written on the papyrus, since its first line indeed states, "This is a story of the search for the wonderful love that began with a dip in the river and ended with a journey in search of the lock of pubic hair…". Apparently, no one saw the picture of the woman after this testimony, since the next time the papyrus is mentioned, it is stated that "on the first, fourth, fifth and eighth pages, there are big holes, and it seems as if pictures or text were cut out of the papyrus."

The division of the papyrus into two parts and their separate sale sounds like a barbaric act, but we should not be surprised. Archeological delegations from the U.S. and from Germany, as well as representatives of the Ottoman (Turkish) government, took part in excavations that were conducted in

Syria and Iraq during the 20th century, leading to the discovery of clay tablets from Assyrian times. Every finding that was taken out of the earth was divided up – or broken, to put it bluntly – into three parts: one made its way to the U.S., the second reached the museum in Istanbul, and the third passed from the Germans' hands into the hands of private merchants. Of course, this does not take into account the fragments that were stolen by the excavators themselves and found years later in the possession of merchants or private collectors. The merchant who sold the Egyptian papyrus earned more money from the two halves than if he had sold the complete papyrus to a single buyer.

After a sale like this, a war of nerves begins: Who will each one sell his half to… and for how much? Apparently, in this case, the war ended without a decisive victory, and each of the buyers remained with half of his craving unfulfilled. However, we know that in 1886, some artist or other copied the second

half of the papyrus, and the two halves – the original first half and the copy of the second half – reached a small museum (that no longer exists) in Moscow, which was known by the name "The Museum with the Blue Door" because its gates were painted blue. It seems that the museum in Moscow, which was

well known for the strange exhibitions that were put on in it, exhibited the papyrus or enabled various researchers to peruse it. The papyrus was mentioned at least once in a collection of German translations of Egyptian papyri (in 1898), and in 1904, the papyrus was mentioned in a booklet that was published in Moscow and raised the question: "Who is the uncultured boor who damaged papyrus number 677193?"

At the beginning of the 20th century, a scandal erupted in Moscow – the museum with the blue door became a pornographic museum! Following an exhibition that included the naked genitals of animals as well as of men and women, sanctimonious demonstrators broke into the museum and the authorities ordered it to be closed. Most of the exhibits were transferred to St. Petersburg. However, our papyrus found its way back to its ancestors: in some unknown way, the Ethnographical Museum in Cairo acquired the papyrus (the first half of it, to be exact), when it was torn and damaged. We did not manage to find any trace of the original second half; even the copy disappeared, and the only thing that is left is a poor translation into German that was found (in two identical versions) in the museum in Cairo and in Stuttgart.

The papyrus that reached Cairo (its original half and its translated half) fell, unfortunately, into the hands of an extremely conservative archeologist or curator – but nevertheless one with an excellent knowledge of Egyptian culture. He gave the papyrus the name by which it is known today – "The Search for the Lock of Pubic Hair" but, on second thought, deleted the word "pubic" and left the name as "The

Search for the Lock of Hair". With the same thoroughness, he deleted, cut out and tore out of the original papyrus every word or sentence to which a sexual interpretation could be ascribed. The literary papyrus became a sieve with more holes than content in it. The damaged papyrus was brutally folded, wrapped in a piece of paper that contained the German translation of the second half, and tossed into a drawer in the museum. In the inventory list, it was noted that the papyrus "…[was] damaged, and [could] not be restored or preserved". In 1997, the papyrus returned to Paris – this time to a company that specialized in restoring ancient texts written on parchment. The researchers in the company's laboratories required papyri in order to investigate the possibility of restoring ancient papyri that had been damaged. In 1999, the papyrus was returned to Cairo along with the "restoration", which was completely worthless.

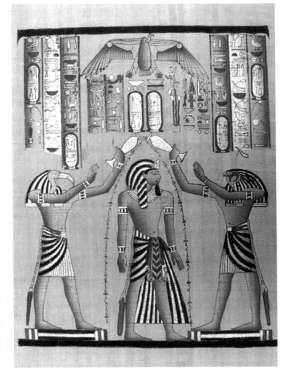

After collecting all the fragments of data linked to this marvelous papyrus, we realized that we were faced with only two possibilities: The first was to try to reconstruct the papyrus scientifically, that is, to exhibit a meaningless mass of literary text, most of which was missing. The second – which is the one we chose – is to tell the literary story that appeared on the sheets of the papyrus, making use of the papyrus, its copies, its translations and the notes on it, in the belief that we could succeed in reconstructing the original story in full. Unfortunately, we were unable to reconstruct the pictures that accompanied the text. Here, then, is the Egyptian version of the story of Cinderella – except that instead of a small foot and a glass slipper, we are looking for a lock of black pubic hair…

The search for the lock of pubic hair

This is the wonderful story of a search for love that begins with a swim in the river and ends with a

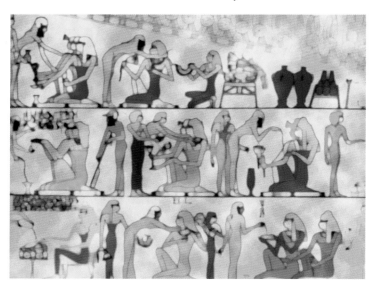

journey in search of a lock of pubic hair that floated on the waters of the big river like a leaf that fell from the treetop. It is the story of the prince A-Re-Mon, the son of the sun, the favorite of the gods, the one who won countless battles and offered innumerable sacrifices to the gods.

One evening, when the daylight shimmered on the calm waters of the river and the summer heat was trapped in the air, A-Re-Mon went down to the river for his evening bathe. He did not wash once, but went into the water and immersed himself three times[1]. The first time, his black slave Samamor scrubbed his body so as to cleanse his master of sweat and dirt. The second time, his female slave Anana combed his hair and anointed it with persimmon oil[2]. And the third time, he went down to the river alone, to calm his mind.

A-Re-Mon was swimming comfortably along the bank of the river, diving into the water every now and then, and listening to the cries of the birds nesting among the reeds on the riverbank. Now and again he heard the voices of the men, women and children who had come down to the water, as he had. He was pervaded by a great sense of tranquillity. Some time later, when the shadows crept over the river, he turned around and swam back to the dike opposite his palace, where he had entered the water. As he

turned around, his eyes caught sight of a black leaf floating on the waters of the river in front of him. A-Re-Mon stretched out his hand and grasped the leaf… but it was not a leaf…

In the prince's hand lay a lock of hair. A lock of hair that was as black as the night. A curly lock of pubic hair. It was customary among the women who reached a marriageable age to hide among the reeds on the riverbank and remove their pubic hair with a razor[3]. This was the first time he had seen a lock of hair carried into the waters of the river, however. When he looked at it, he thought that he had never seen anything more beautiful. And if the lock of hair was so beautiful, how beautiful were the genitals it concealed beneath it? And if the exposed genitals were beautiful, how beautiful was the woman who hid them beneath her robe?

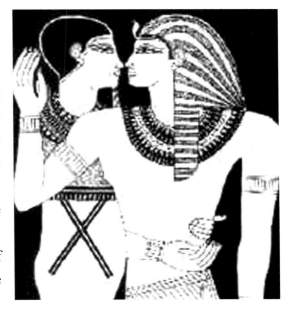

Still holding the lock of hair in his hand, the prince scanned the riverbank, but did not see anyone among the reeds.

"I must find her… whoever she may be!" he muttered to himself and turned toward his palace, swimming with all his strength in the waters of the river, the lock of hair clutched tightly in his hand.

When he reached his palace, the prince handed the lock of hair to Anana, the slave, and, following his instructions, she dried it, perfumed it, and placed it on a bed of linen in a small golden box the prince had received from the Pharaoh. She placed the box at the prince's bedside.

That whole night, the prince tossed and turned in his bed, his body wracked by stormy dreams. Up until then, he had had three wives and countless concubines, but now he did not have a woman, and only one image filled his heart – an image without a face or a body, an image that had been conjured up in the waters of the river by a single lock of pubic hair…

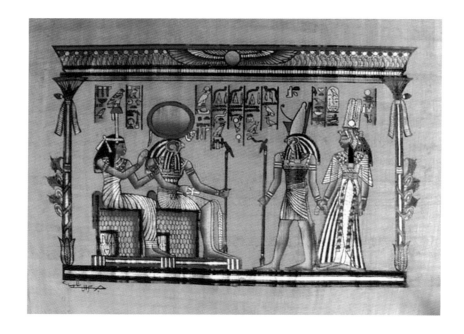

When dawn broke, the prince called his officers and issued a decree: for the next forty days[4], no girl or woman – married, single or slave – was permitted to leave her village in his entire administrative district. And during those forty days, no girl or woman was allowed to remove her pubic hair. Horsemen were immediately dispatched to enforce the decree throughout the district and in all the villages that were ruled by Prince A-Re-Mon.

Forty days and forty nights passed, and each evening the prince would stare at the black curl, anointed with oil, that lay on the bed of white linen in the golden box. And every night he lay tormented on his bed. Forty nights he did not sleep with a woman, forty days he did not go hunting, and forty mornings he woke up with sadness in his heart…

At the end of the forty days, Prince A-Re-Mon ordered all the girls and women in his district to be brought to the palace. As he sat on his royal throne, the golden box at his side, the women passed in front of him, one after the other, displaying their genitals to him. Some women had thick pubic hair, others had fine down, some had open genitals like the gates of a city, others had closed genitals like a miser's money-box. There was pubic hair that was as prickly as a hedgehog, there were genitals that were as rounded as humps[5], there were perfumed genitals and fragrant genitals… Each woman who passed in front of him received three silver coins, because the prince did not want to shame them without paying them[6]. And even though he had not slept with a woman for forty days and forty nights, he did not feel any desire, nor did he feel any excitement in his heart. There was not one among them whose pubic hair reminded the prince of the lock of hair in the golden box.

"Are those all the women in the district?" asked A-Re-Mon after the last one had left his presence.

"Indeed, my lord… except for one more, who refuses to display her pubic hair!"

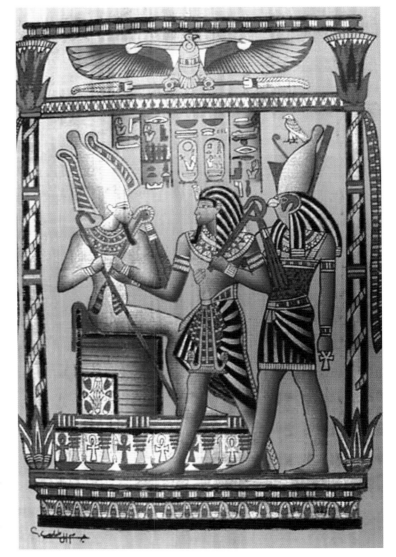

"Bring her to me!" raged A-Re-Mon and took a sip of wine from the jug in front of him.

Two of his servants brought the girl, her body covered in a long white robe. She lowered her eyes in front of the ruler.

"Who are you?" asked A-Re-Mon impatiently.

"My name is Sariq, and I am the only daughter of my widowed mother," she replied, raising her eyes.

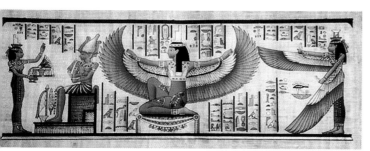

And when the prince saw her eyes, as brown as the good earth, he forgot his anger.

"Why did you not come here with the other women?" he asked gently.

Without hesitating, she replied: "We were told that we would have to expose our genitals in front of the ruler, and I made a vow[7] to expose my body only to my husband – if I ever have a husband!"

Prince A-Re-Mon pondered her words and thought that of all the women of his district, this girl was the only one that had not sold her honor for money, and had not submitted to the ruler's decree. However, he was still the ruler, the scion of the Pharaohs, and anyone who disobeyed his rules had to be put to death!

"Go with my slave, widow's daughter," said the prince eventually, "and remove a lock of your pubic hair. In that way, you will fulfill your obligation."

No sooner said than done. The slave took her to the pool of water in the heart of the palace where she removed a lock of her pubic hair, placed it on a platter, and sent it to the prince. When the prince took the lock of hair and placed it in the box next to the lock he had taken out of the water, he could not differentiate between them.

"She's the one!" he shouted. "Bring her to me!"

And so Sariq returned to the prince, who ordered her mother to be brought to him, so that he could ask her daughter's hand in marriage. Their marriage was celebrated that same night. Before they went to bed, Prince A-Re-Mon placed the two locks of hair in the incense burner and set them alight. When they went to bed, he saw that her exposed and perfumed pubic hair was more beautiful than any he had ever seen – because it was full of desire[8], and upon seeing it, every man would be as virile as a lion[9]. Since the prince possessed an insatiable organ[10], the girl's genitals were a source of life-giving water[11] for him forever and ever.

Prince A-Re-Mon and his wife Sariq spent two decades together, and they had two sons and two daughters. When he was 57 years old, he went out into the desert with his warriors in pursuit of pirates, and he was bitten to death by an asp. While his body was being prepared for burial, a little bag was found on his chest. It contained a perfumed lock of pubic hair, a lock of hair belonging to the woman he loved more than anything.

1 The Egyptians' foul body odor is described in many places, and various travelers asserted that the Egyptians did not bathe. This is not true. The Egyptians were in the habit of bathing in flowing water three or five times a day. It is true, however, that some of them applied various oils whose odor was unfamiliar to the European and Asian travelers. (Some of the oils served as protection against the bites of reptiles and insects.) Bodily hygiene was one of the Egyptians' daily chores.

2 Actually, the German translation speaks about an apple. It seems that the reference is to oil that is extracted, for instance, in Ein Gedi, on the shores of the Dead Sea, and is mentioned in the Song of Songs in the Bible.

3 In ancient Egypt, the custom of shaving the pubic hair for both men and women (as well as shaving armpit hair in women) changed during various periods, as we learn from the study of paintings and of papyri. In a medical papyrus from the 17th century BC, we find precise instructions for shaving women's pubic hair and armpits, including instructions for mixing salves for softening the hair and the skin before and after. In another source from the 10th century BC, we find a tip for women "to leave a thread [a narrow strip] of hair rising from the genitals" in order to "catch men's eyes". In a medical papyrus from the sixth century BC, the practice of hair removal is denounced, and there is a description of serious injuries caused by cuts in the genitals. In books of dream interpretation that seem to have been written 4,000 years ago, there are dreams that specifically mention female genitals "whose hair is missing", "whose hair is dyed", and so on.

4 "Forty days" is a ceremonial number, but it is also mentioned in a medical papyrus in the context of pubic hair. In the case of pubic lice, it is recommended that the hair be removed with a razor and that various ointments be applied. After forty days, the treatment should be repeated. In other words, forty days is the time it takes for pubic hair to grow again.

5 This refers to genitals in which the clitoris protrudes like a hump. The same description and the same name appear in various Muslim and Jewish erotic writings, in which the clitoris is called a hump or a hump-back.

6 In ancient Egypt, as in many other places in the ancient world, the compensation received by women for injuries inflicted by men, including rape, was monetary. Here, the payment of the money attests to the fact that the ruler was aware that his deed was damaging both to the women and to their honor.

7 During certain periods and in certain places in ancient Egypt, girls who had reached a marriageable age – that is, they had menstruated and their pubic hair had grown – and were not married, were considered to be permitted to men. In order to defend their honor and their bodies, girls would go to the priests and take a vow. The vow protected them from men who wanted to harm them.

8 We translated the Egyptian name into the Arabic name Il-Talb and then into the word "desire", since this refers to female genitals that have not known a man either ever or for a long time (because of virginity or abstinence), and as a result they burn with desire and embrace the man unceasingly.

9 According to the Egyptians, the lion is the most sexual male in the animal world.

10 Here too we have made use of the Arabic term Il-Hormaq, that is, an organ that does as it pleases and seeks to satisfy its desire.

11 The ancient Egyptian medical texts differentiated between two types of fluids that flow from the female genitals during intercourse: the first fluid is "juice", which is honey-colored and is mentioned in several places as a prerequisite for pregnancy; the second fluid is clear and it is mentioned in the context of passion.

Twelve ancient Egyptians gods

Re sun god of Heliopolis, became a state deity in the Fifth Dynasty, some traditions made him the creator of men, and the Egyptians called themselves "the cattle of Re."

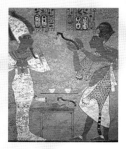

Osiris god of the earth and vegetation, symbolized in his death the yearly drought and in his miraculous rebirth the periodic flooding of the Nile and the growth of grain.

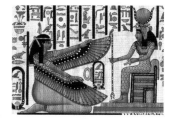

Isis wife and sister of Osiris, gifted with great magical powers, protector of children and therefore one of the most popular gods.

Horus the falcon-headed god, holds in his right hand the ankh, the symbol of life. The kings of Egypt associated themselves with Horus, the son of Isis and Osiris.

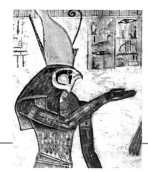